The Ruins

Coming across a ruined building, standing empty and abandoned, always gets the imagination going. To walk where others have walked, to find steps that people from the past have worn away or to run a hand along a wall that has stood for centuries awakens an atavistic sense of our place in the great scheme of things – of time passing, of transience, of the alchemy of history. Here are a just a few ruins to be found in Sussex, and despite the back cover's caveat of the author avoiding the obvious and well known, several of Sussex's more famous ruins just had to be included.

Fallen Fort

Bramber Castle, dating from Norman times, has now almost completely disappeared, except for its central motte, part of a tower, some curtain walls and a few shells of rooms. It was built just after the Battle of Hastings, in around 1070, with William de Braose as its first lord. Erected to defend a river (today the Adur), it's Grade I listed, but has no visitor facilities except a small car park, standing as it does in a virtually derelict, though highly picturesque, state.

It's interesting to speculate just how long it would have taken to build the different parts of a castle a thousand years ago. With Bramber, to build just the central motte, which rises some 30 feet in the centre of the castle site, it probably took – with a hundred men, working ten hours a day – about nine months to complete, allowing for bad weather and seasonal conditions. Most of the earth would have come from the ditch encircling the castle, creating a dry moat around the whole site. Despite the proximity of the river, it's always believed that Bramber's moat was a dry one. Remember, these were pick and shovel times, and all this building work would have taken place with very basic rope cranes and lifting gear to aid construction.

The most prominent feature is the remains of its gatehouse tower. Still lingering on at almost its full 75-foot height, a single window and some holes for floor joists remain within the structure. Even the great hurricane of 1987 couldn't topple it. Beyond are remains of some living quarters and a guardhouse; some pillars of a doorway can be made out, but little else. Most of the stonework that's left is what's known as rough infill, the better-quality 'dressing' stone having long since

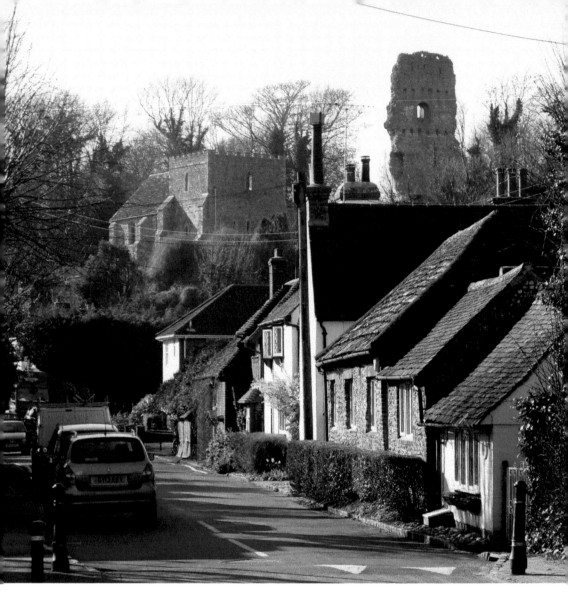

Castle ruins and church at Bramber.

been dug out and taken away for use elsewhere. A short distance away are a few sections of exterior walls, standing to a height of some 10 feet in places. The dry moat still surrounds the castle and is a good circular walk for those energetically inclined.

During Norman times, Bramber Water (now the River Adur) was much wider and deeper, and at high tide fair-sized ships would have been able to reach Bramber, which was a small port. The castle's location was perfect for defending this and the much larger port at nearby Old Shoreham.

Sitting under the main bulk of the castle is St Nicholas Church – once the castle chapel. It was originally built in 1075 and housed a small Benedictine college. It is the oldest Norman church in Sussex. Part of the original nave remains, but the

RUINS, REMAINS AND RELICS: SUSSEX

CHRISTOPHER HORLOCK

AMBERLEY

First published 2022

Amberley Publishing, The Hill, Stroud
Gloucestershire GL5 4EP

www.amberley-books.com

British Library Cataloguing in Publication Data.
A catalogue record for this book is available from the British Library.

ISBN 978 1 3981 1114 1 (print)
ISBN 978 1 3981 1115 8 (ebook)

Typesetting by SJmagic DESIGN SERVICES, India.
Printed in Great Britain.

Contents

Introduction

Sussex is a fascinating county, saturated with history, legends, stories and mysteries. There are remains of these aspects everywhere – a curious relic preserved in a church, an unusual grave outside, some ruinous building down the road, a bizarre artefact in the local museum. Author Christopher Horlock has been travelling round Sussex for many years, photographing these features and researching the stories behind his findings. Added into the physical mix are a number of myths, legends and facets of folklore that further enrich the tales and reveal something of the mindset of the people of Sussex's past.

But don't expect to find the obvious tourist spots or items that always turn up in guidebooks or travel publications. The accent, with a few exceptions, is on the unusual, offbeat and decidedly quirky. The scale of the remains featured is equally surprising, ranging from a ruined castle to a simple, single spoon.

Some may think this 'bits and pieces' approach to history, although interesting, is somewhat limited and collectively doesn't amount to much. However, fellow Sussex author David Arscott makes a good case for such 'blatant randomness' in the introduction to his book *Hidden Sussex Day by Day* (1987). He writes convincingly that the stories behind such remains:

> ...ceaselessly criss-crossing, subtly infect one another as they pass: there is a fruitful cross-pollination of atmosphere and reference. Little by little an impressionistic history materialises, and one that includes the trivial as well as the obviously portentous. No event, as no man, is an island entire of itself. Follow a thread into a labyrinth and surprising connections are made, themes emerge, simple facts find an even richer context.

Some remains that readers will be expecting to find, such as the Long Man of Wilmington, Bishopstone Tide Mills or the Piltdown skull, won't be found, however significant, as they appeared in the author's previous Sussex title, *Illustrated Tales of Sussex* (2017). Equally, other curiosities must wait for a future book, such as follies (many in the Brightling area), Walter Potter's museum of stuffed animals at Bramber and the table in the Anne of Cleves House Museum, Lewes, which once developed a life of its own following the murder of Thomas Becket in 1170.

So, prepare to travel across the length and breadth of Sussex, taking a look at some of its more unusual curiosities.

Above: The overgrown motte at Bramber Castle.

Below: The church at Bramber, once the castle chapel.

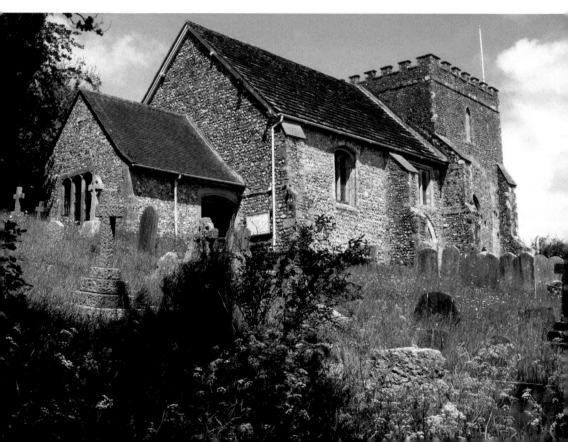

church was in substantial disrepair by the seventeenth century and the Victorian 'restoration' is considered a rather clumsy job.

Except for a period of confiscation during the reign of King John (a very stroppy king, but popular in Sussex for some reason), Bramber Castle remained in the ownership of the de Braose family until the line died out. Then a John de Bohun inherited the building (his wife, Aline, was daughter of the last de Braose) and the family subsequently married into the famous Howard family, who became the dukes of Norfolk, still based in Sussex today. The castle was used for a time as a prison; there's a record of two pirates being incarcerated in 1355, but they escaped.

However, due to the continued silting up of the river at Bramber, the port at Old Shoreham was moved downriver and the castle was abandoned by its last owner in 1394 (another de Braose) and soon fell into disrepair. Little is then known of its history, and by the late 1500s it was being described as 'a heap of ruins'. During the Civil War, there is a mention of some sort of skirmish at the castle, around 1642, which we can only guess at. There is no evidence that Oliver Cromwell, Parliament's champion, ordered the roof of the church to be used as a gun emplacement to fire on Bramber Castle, but it is a much-repeated story. This would have been to disable it as a stronghold for any Royalist troops in the area, but as it was already a ruin this would have been pretty pointless. The remains were further plundered over the years for building materials. In 1925, the Duke of Norfolk sold the castle to the National Trust, but English Heritage has managed it since the 1970s.

Castle Without a Name

While we know a great deal about the county's castles, one at Midhurst remains very mysterious and seems to have 'slipped through the net' as regards research and excavations. The information plaque at the site simply refers to it as 'A Norman Castle'. Until early in the last century nothing of it was even visible. In 1913, footings were unearthed and built up above ground level, revealing the outlines of the some of the walls that made up the castle's hall, kitchen, chapel and a storage area. It's thought the first buildings on the site were wooden, replaced by stone buildings in the twelfth century, to make a fortified manor, but on a mote-and-bailey pattern, a central mound containing the defensive keep and residential buildings, an outer courtyard for animals, stabling, etc. Incidentally, from its foundations, the keep seems to have been either an odd shape or was rebuilt several times.

It's not known who built the castle, who resided there or why it was so totally obliterated. There were limited excavations in 1994, but these only threw up more questions than answers. As the information plaque states: 'Only future investigations can resolve them.'

Midhurst's mystery castle.

Fallen Priory

The ruins of the Priory of St Pancras, at Lewes (Grade I listed), set in Priory Park, are but fragments of the original complex, decimated when a railway line was constructed across the site. Under William I, Lewes was the seat of William de Warenne, who founded the priory with his wife, Gundrada. It was the first Cluniac priory in England and dedicated to St Pancras, who was a Christian martyr in Roman times, executed when just fourteen years old. De Warenne made a pilgrimage to Rome around 1075 and, passing through Burgundy, was awestruck by the abbey of Cluny, dedicated to his memory. Discovering that the pope was a Cluniac, he became set on building a Clunaic house in Britain. This duly took place at Lewes between 1078 and 1082 and in time became one of the wealthiest monasteries in the country. A great priory church rose on the site, larger than Chichester Cathedral, but would become the main casualty when the 1845 railway line between Lewes and Brighton began to be excavated. Two lead caskets were unearthed containing the remains of de Warenne and his wife, which were transferred to the church of St John the Baptist in Southover High Street.

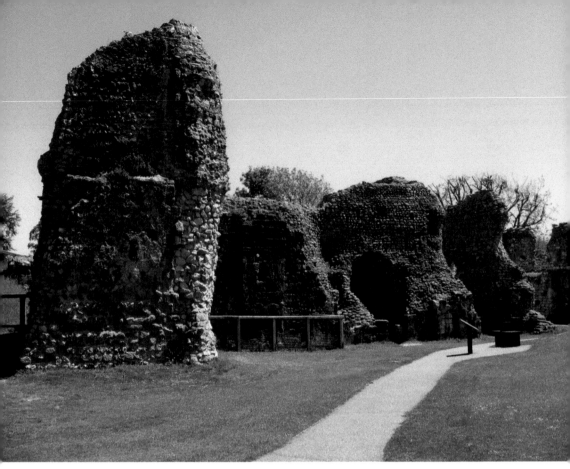

Part of Lewes Priory.

There are excellent websites about the priory, detailing, with some startling recreations of its appearance, all its features and amenities and how it was closed down during the Reformation, the start of its slow demise, passing into the hands of Thomas Cromwell, Henry VIII's Secretary of State and, ironically, the main individual responsible for its downfall.

School's Out

If you go down to the woods today – at Bedham, near Petworth – you're sure of a big surprise. This building, now left to the elements, served for some eighty years as both Bedham's school and chapel. It was built in 1880 by a local landowner, employing, at one period, three teachers, with sixty children attending lessons. A large curtain divided infants from seniors. On Fridays, all the school chairs were turned round to face east and the ink pots removed from the desks in readiness for Sunday services, which were conducted by the rector of Fittleworth. Music for the hymn singing was provided by a local woman playing a harmonium. However, pupil numbers fell off due to the declining rural population and by the

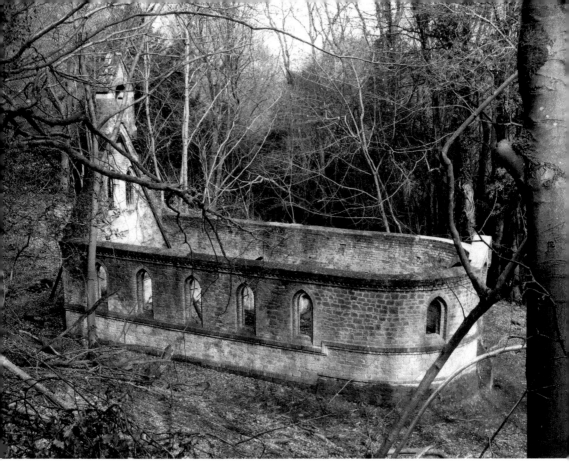

Bedham's derelict school.

First World War the building was in disrepair. It was reported that the state of the girls' earth closet was found to be 'very offensive indeed'. The building closed as a school in 1925 but continued holding one or two church services a month. The final event was a wedding in 1959. Since then, the building has been robbed of its roof tiles and metal window frames and the bell tower supported to prevent collapse. However, it's still possible to see where the children hung their coats and a single fireplace remains intact, which once warmed the whole building. On a still afternoon in the autumn the atmosphere is such that you almost fancy faint chanting can be heard of children going through their multiplication tables or reciting the Lord's Prayer.

A Ruin Cromwell Knocked about a Bit?

A now largely forgotten novel, *Brambletye House; or Cavaliers and Roundheads*, by Horace Smith, published in 1826, featured this house, standing just north of Forest Row, making it a hotbed for conspiracies against Parliament during the Civil War. This was when Oliver Cromwell sought to remove 'the divine right of

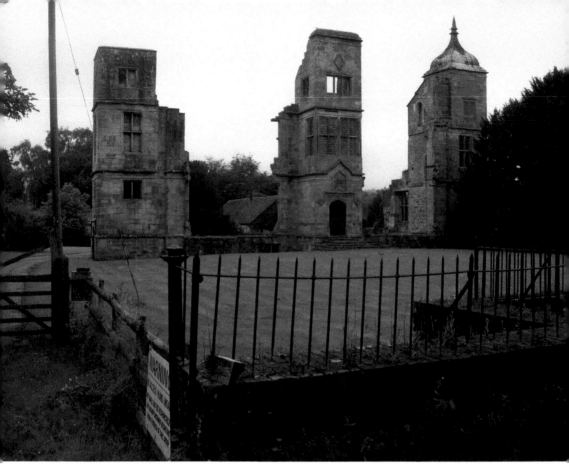

Remains of Brambletye House.

kings' from Charles I and establish a more democratic way of ruling the country. He eventually succeeded, leading to the execution of the king in 1649.

The ruins of the house still stand and the date '1631' remains discernible above the front door. It was built by Sir Henry Compton, MP for East Grinstead, who really existed and lived there, but, according to Smith in his story, masterminded all manner of plots in support of the king during the conflict, with a group of equally fervent Royalists meeting up in secret to assist him. Smith provides a dramatic scene when all has been revealed and the game is up. Compton is out hunting when servants catch up with him, reporting that Parliamentary agents are on their way to Brambletye bearing a warrant for his arrest on a charge of high treason. Without batting an eyelid, Compton turns on his horse, rides off to the nearest port and sails for the Continent, never returning to England and never seeing his house, wife or family again. On hearing of his escape, Cromwell ordered the house to be partially demolished as an example to anyone else planning resistance to his regime, and it stands that way today – more or less as it was left.

While it's a good story (and Henry almost certainly was a passionate Royalist), the facts don't fit with it, as the house was still intact and being lived in, even at the

time of Cromwell's death (1658) and the subsequent Restoration. It's probably a later occupier of the house, from the 1680s, Baronet Sir James Richards, who fled the country for Spain on a treason charge, abandoning Brambletye and leaving it to rack and ruin.

Trouble at Mill

Sussex has a number of windmills still operating, lovingly restored by volunteers and open at various times of the year for the public to visit. However, the one here, at East Wittering, a tower mill built of brick, stands forlorn and a near ruin. The first record of it dates from 1810, but it could be earlier. It had two pairs of grindstones and was worked until 1895, when the sails were removed. The cap (roof) blew off in a gale in 1931 and fire gutted the remains in 1975. Despite its poor state, it's still a Grade II listed building. More Sussex windmills are featured later in the 'Remains' section.

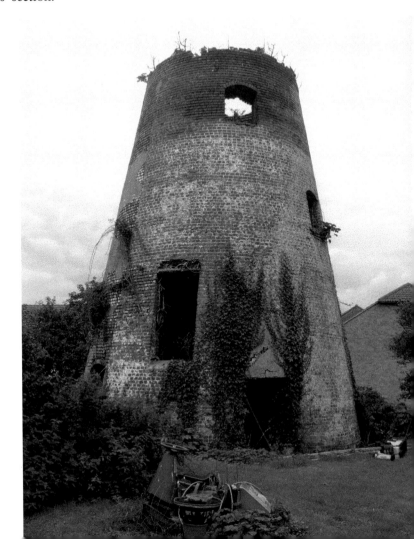

The ruined mill at
East Wittering.

House of Fire and Death

Cowdray House, at Midhurst, is one of the county's best-known ruins and its demise, according to legend, came about because of a curse. There are variations on the story, but the 'best fit' version goes as follows, starting back in Tudor times. During the Reformation, a neighbouring monastery passed into the hands of Sir Anthony Browne, owner of Cowdray, and he had all the monks instantly expelled. One of them is said to have cursed the family (obviously forgetting all his Christian ethics), saying, 'By fire and water thy line shall come to an end and it shall perish out of this land.' Or words to that effect. Browne's successor, his son of the same name, was created 1st Viscount Montague in 1548. Fast forward to 1793 and the house is engulfed by fire and burnt down when careless workmen start a fire in the north wing. Some irreplaceable paintings went up in the blaze, including several by Holbein. A few months later, while the young 8th Viscount Montague was in Germany, he decided to negotiate the Schaffhausen Falls on the Rhine. His boat was too small and he capsized at the second cataract and was never seen again.

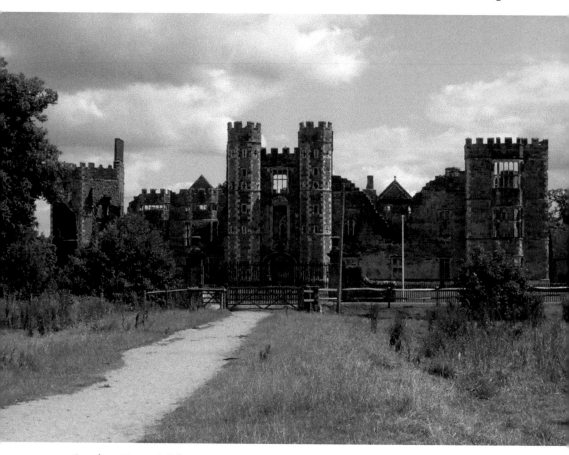

Cowdray House, Midhurst.

News of the fire back home hadn't reached him. He was succeeded by the 9th Viscount, who died childless so the family line died out and the curse was fulfilled. Fire and water had wiped the family and its house out, but had taken over 200 years to take effect. Just a good story? Of course it is.

Lost Glory

Few attending a funeral at Worthing Crematorium, just off the Horsham Road, near Findon, realise they stand where there used to be the tennis courts of an impressive country house – Muntham Court.

The first house on the site was built in the fourteenth century, but a substantial hunting lodge went up in 1743, built by Anthony Browne, Viscount Montague, of Cowdray House (previously mentioned). This was acquired in 1765 by William Frankland, a retired East India merchant and a descendant of Oliver Cromwell. He was an avid enthusiast of all things mechanical and filled the house with numerous gadgets, devices and machines, and is remembered still in the name of the pub at Washington, the Frankland Arms. After his death in 1805 the house came up for sale several times, with the estate, in 1835, extending to

Muntham Court.

Site of Muntham Court today.

over 1,680 acres, straddling what was then still the turnpike road to London, the present A24.

Harriet Thynne, Dowager Marchioness of Bath, bought the estate in 1850, when the house was still a brick-faced property. It's said that on seeing it, she remarked: 'The upper classes do not live in red brick,' and had the whole house redesigned and refaced in flint, leading to the very attractive neo-Jacobean appearance seen in the picture. A chapel was added, but somewhat incongruously it was entered by passing through the billiard room.

Lady Bath died in 1892 and her second son, Henry, inherited the house. On his death his widow acquired the property, but it finally passed to their son, Colonel Ulric Thynne. He'd already had a distinguished military career, so when the First World War was declared he was soon called on to command the Royal Wiltshire Yeomanry. His four children spent their formative years at the house, with Brian Thynne taking a key interest in flying. Despite no proper landing strip and a decidedly irregular terrain, he took off and landed at Muntham many times, inviting his aviation friends to do the same. This all came to an end when the Second World War got underway and much of the estate was occupied by military personnel. In fact, in 1942, in preparation for D-Day, the whole area of the Downs above Findon was requisitioned by the War Department and sealed off to the public. Muntham

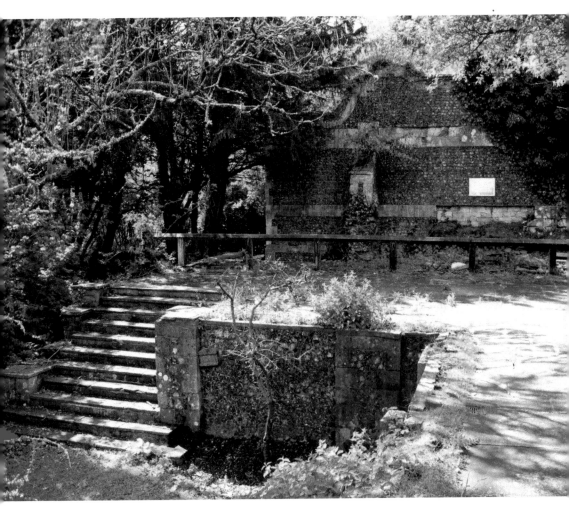

Remains of garden steps and a wall from Muntham Court.

House was still occupied by the family, but run down to a handful of servants and social activity was limited to a weekly sewing group who made comforts for the RAF and Wiltshire Yeomanry. The colonel led a local *Dad's Army*-style Home Guard group, vigorously patrolling the Downs looking for enemy parachutists.

Colonel Thynne died in 1957. The following year the family put the house and the 1,000-acre estate up for sale. Everything was sold off, in thirty-six lots, with the house going for £10,000. It was bought by a firm named Allenside and Co., who had plans to convert it into a private crematorium, but this proved impractical. Other ideas came and went, including making it a country club, flats or a hotel, and at one point it was rumoured that actress Diana Dors was interested in buying it as her own private residence. Eventually, Worthing Council acquired it, planning a new, state-of-the-art public crematorium on the site. All of the house's internal fixtures and fittings were sold off prior to demolition.

Muntham Court came down in 1961 and (fortunately) several features survived and still can be seen today. These include the garden terraces and steps, a monogrammed section of wall, the mansion's icehouse and, somewhat chillingly, the family graveyard. The graveyard is on a small hill to the south-west of the site in among a clump of trees; the Thynne family graves are in a line, with servants and staff occupying a separate area. Brian's grave is there, the aviator, the last incumbent, who died in 1985.

Fighting Fort

The shell of Shoreham Fort stands at the mouth of the River Adur, where an enthusiastic group of volunteers continues to excavate and renovate, hoping one day to restore the whole structure to how it looked back in 1857 when it first came 'on station'. It was built, like Littlehampton Fort and the one at Newhaven, to counter any invasion threat from the French. In the 1850s France was ruled by Napoleon III (1852–73), a nephew of the famous Napoleon who had tried to subjugate Europe earlier in the century. When a major refitting and modernisation of the French fleet took place, Britain because suspicious that this could be the start of another invasion plan.

Shoreham Fort.

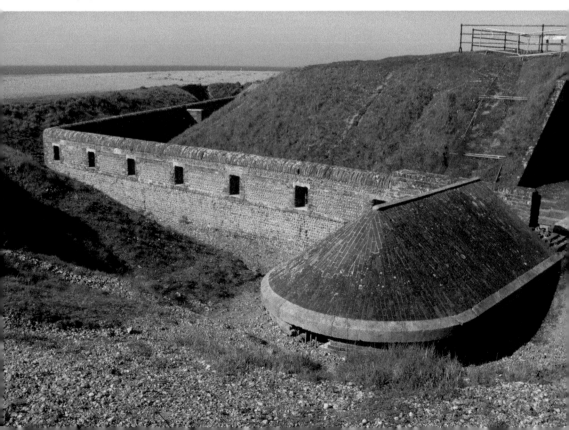

Shoreham Fort was manned by men of the 1st Sussex Artillery Volunteers, who had state-of-the-art guns to use. Before, a typical cannon could fire shot around 800 yards. The six guns installed at Shoreham could reach 4,000 yards, so easily tear into ships way out at sea. Any landing party would have to negotiate a 15-foot ditch, then a 12-foot-high wall, as well as continual rifle fire, to take the fort. The building was well appointed, with its barrack block (demolished in 1958), housing stores, officers' quarters, a guard room, prison cell, kitchen, cook house and dormitories for thirty-five NCOs and privates.

The fort was manned for around fifty years but never saw an attack. In the Second World War, a battery of modern guns was installed, but subsequently the fort was abandoned and dismantled and gradually became a ruin. Today, as well as the restoration work, the Friends of Shoreham Fort stage some lively open days during the year, where guided tours take place, military vehicles are on show, children attending are taught some basic drilling by an 'I'm having no nonsense from you lot' Sergeant Major, and it's even been known for Queen Victoria herself to appear and inspect the troops. The highlight of the day though is when the full firing of a period gun is demonstrated – an unforgettable experience.

Cementing the Future

Situated on a site covering some 100 acres, the cement works at Beeding, standing on the A283 road from Shoreham to Steyning, has sometimes been described as

Beeding cement works.

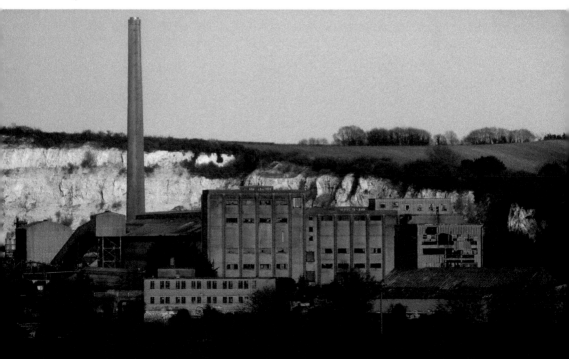

resembling an old James Bond movie set. Chalk was first excavated from the area during the early nineteenth century, with the Beeding Portland Cement Works starting cement manufacture in 1883. The location was ideally located next to the River Adur, wider and deeper then, with the raw materials needed for production (clay, sand, gypsum, plus coal) arriving by barge. The works also had their own railway sidings, connected to the Shoreham to Steyning line, which ran west of the site, next to the river. The works were expanded several times under different owners, but the huge buildings seen today date from the late 1940s.

Blue Circle Industries owned the works from 1978, with over 300 employees by 1981, but the machinery became dated, output limited, and the factory proved uneconomic to keep going, so closed in 1991.

All sorts of plans have come and gone for redeveloping the site since then, including the creation of a new, £1.3 billion eco-village in the area, to be known as Erringham, featuring over 2,000 houses, a health centre, shops, offices, a school and an outdoor activity centre. Another idea was to create a massive sports complex incorporating the largest dry ski slope in Britain, as well as facilities for ice skating, swimming, water sports, rock climbing and skateboarding. A further scheme involved the creation a South Downs National Park visitors centre, with camp sites, a youth hostel, shops, a café, stables and bike centre. None have

Close-up of the abandoned cement works.

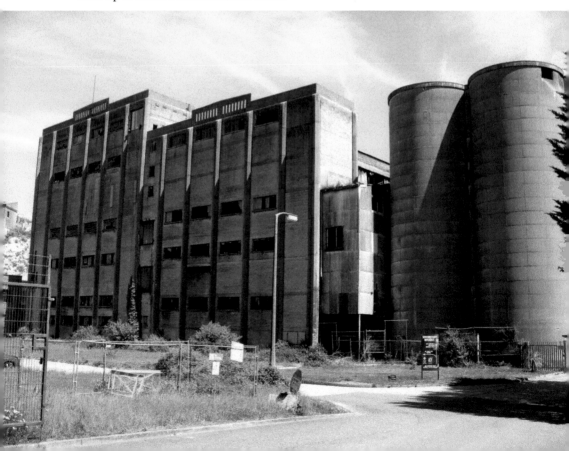

materialised and at present the derelict factory belongs to the Hargreaves Group, who lease out some of the hard standings and intact buildings to a number of small businesses.

The West Pier

Perhaps the most photographed ruin in all of Sussex, at least while it remains standing, is what's left of the West Pier, Brighton. It was opened in 1866 as a basic promenading deck, but was later extended and added to, with a concert hall at the seaward end built in 1893 and a central concert hall in 1916. It was at the height of its popularity immediately after the First World War, with the recorded figure of 2,074,000 visitors achieved during the 1919–20 season. Neglect, lack of maintenance and massive indifference by its final owners eventually led to the pier head area being declared unsafe and closed off in 1970. Five years later the whole structure was declared dangerous and closed down in September 1975. There then followed an incredibly prolonged effort to save the pier – too complex and tedious to relate here. The West Pier Trust was formed in 1978 to oversee restoration. Lottery money of £14 million was secured but would only be forthcoming if it was matched by the trust – money it didn't have. Developers came and went, so did dates for restoration and reopening, but nothing happened and parts of the pier collapsed.

Wreck of the West Pier.

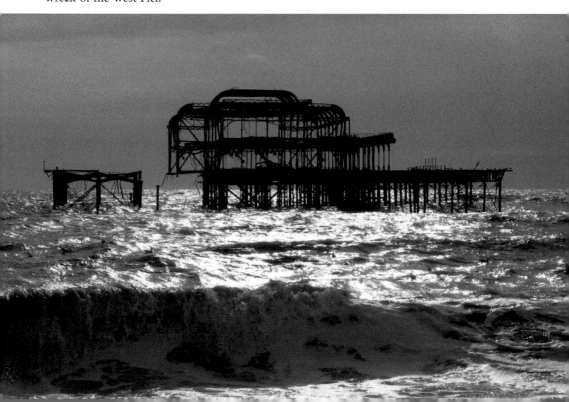

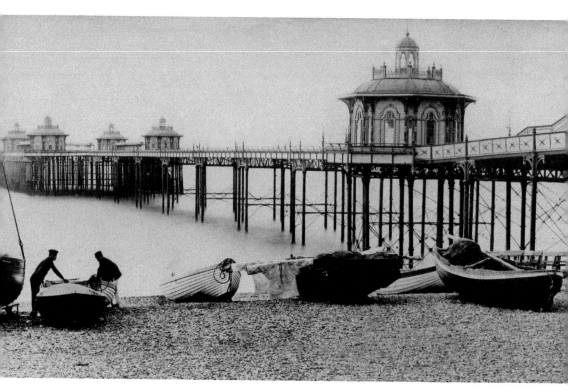

The pier in its original form, *c.* 1870.

Everyone knows how the saga of the West Pier ended. Brighton has been awash ever since with speculation about who was responsible for the fire of 2003 and what was obviously a deliberate arson attack. The pier was completely unique and irreplaceable (the only Grade I listed pier to exist) and nothing like it will ever be seen again. Nationally, it was up there with Stonehenge, the Tower of London and Brunel's Clifton Suspension Bridge. There is a huge irony in the fact that Hastings Pier was lost to fire damage in 2010, yet the will and money were found to restore it.

The Remains

This section starts with a number of tombs and memorials, then moves on to other remains, mostly buildings or parts of buildings both large and small – some just a leftover space or area. All are of historical significance, with many revealing a great deal about the beliefs, attitudes and outlook of people from the past, which can be compared and contrasted to the preoccupations of society today.

Silence is Golden

The grave of Samuel Sparrow, found in the churchyard of St Wilfrid's Church, Haywards Heath, informs us he died on 13 January 1913, aged seventy-eight. The words 'Peace Perfect Peace' are inscribed on his tombstone. Was someone having an ironic moment when this was chosen? From 1880 to 1894 Mr Sparrow was the church organist.

Samuel Sparrow's grave, Haywards Heath.

Just As She Was

In front of St Andrew's Church in Hove is the Elliott family's vault. Here lie the remains of Charlotte Elliott (1789–1871), who wrote the famous hymn 'Just As I Am'.

Charlotte was born at Westfield Lodge, Brighton, into a family of church ministers and developed a passion for art at an early age, becoming an accomplished portrait painter. She also showed a distinct talent for writing verses, mostly of a humorous kind. However, illness dogged her throughout her life and despite her religious siblings she had deep uncertainties about her own faith and beliefs. She asked a minister visiting her father how she should come to Christ and was told: 'Just as you are.' From that day she became a fully devoted Christian.

Following the death of her father in 1833, she took over editing *The Christian Remembrance Pocket Book*, a religious annual, and in 1836 editorship of the *Invalid's Hymn Book*. She edited the *Remembrance* title for twenty-five years and many of her poems featured in it. It was in the 1836 edition of the *Invalid's* book, clearly based on the advice she'd be given by her father's friend, that 'Just As I Am,' appeared:

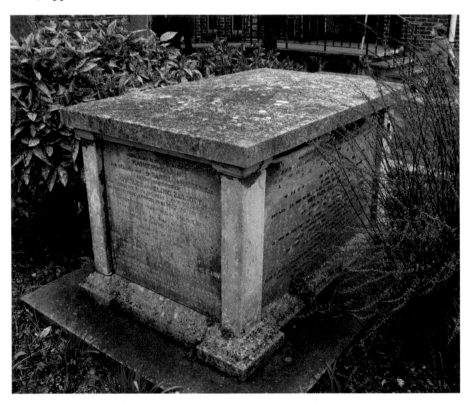

Charlotte Elliott's tomb.

Just as I am, without one plea,
But that Thy blood was shed for me,
And that Thou bid'st me come to Thee,
O Lamb of God, I come! I come!

Towards the end of her life Charlotte lived at No. 10 Norfolk Terrace, Brighton. Her brother, Henry Venn Elliott, was the founder of St Mary's Hall in Brighton, a girls' school, now part of Roedean. She was also a distant relative of Virginia Woolf.

International Rescue

In the churchyard at Selmeston, immediately right of the main door, is the grave of Frederick Stanley Mockford, the man who devised the 'Mayday' emergency signal. He was born at Seaford in 1897 and while working as a senior radio officer at Croydon Airport was asked to come up with a new international distress signal that could be used over the radio instead of the old Morse code SOS, which was often difficult to make out. The bulk of traffic coming into Croydon Airport was

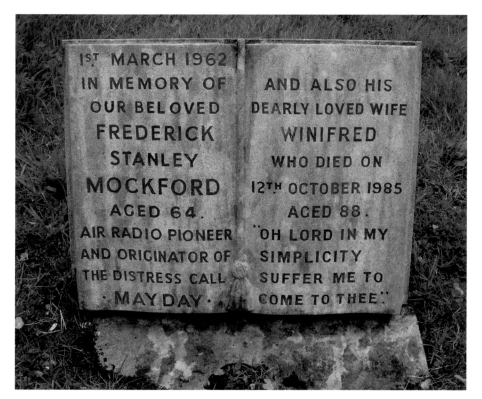

Stanley Mockford's grave, Selmeston.

from France, so Mockford used the French *m'aider* as the basis for the new signal, repeated three times, which is the shortened form of *venez m'aider*, meaning 'come and help me'. The signal he devised, in 1923, soon spread to other countries; in time it became an international distress call used throughout the world.

Brassed Off

In Etchingham's church is this brass depicting Sir William de Etchingham, who built the church in 1358. The head part has been missing since the late 1700s. It's claim to fame? It happens to be the oldest brass in the whole of Sussex,

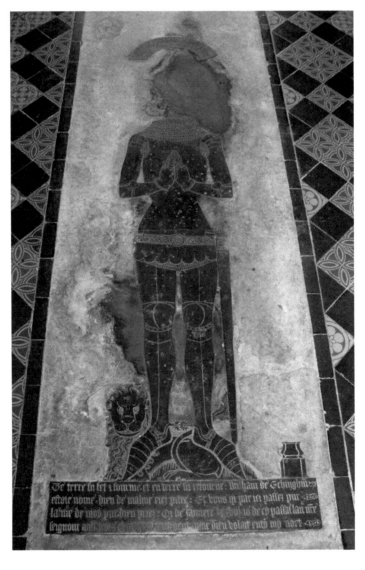

The oldest Sussex brass at Etchingham.

dating from 1388 or the year after. The inscription reads: 'Of earth I was made and to earth I have returned. William de Etchingham was my name: God have pity on my soul. And you who pass by, pray to God for my soul, which passed away, as God willed, about midnight on 18th January in the year of Our Lord 1388.'

Blessed Relief

Another unique feature of Etchingham Church is a series of pews known as misericords, the second longest in the county (those in Chichester Cathedral are longer).

Misericords – the word comes from the Latin, meaning 'to have pity on' – were small shelves on the undersides of folding seats, installed to provide some relief for those who had difficulty standing for long periods during church services. The old or infirm could lean back on the shelf and it would support them while standing. In the distant past, periods of prayer could be extremely lengthy and were almost always said stood up with hands uplifted. Misericords were usually intricately carved, sometimes with amusing scenes, despite being out of sight most of the time.

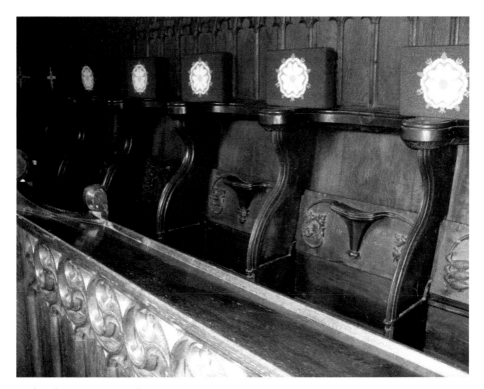

Etchingham's misericords.

Emergency Exit

This ancient, blocked-up doorway can be seen on the western side of All Saints' Church at Lindfield. It's tiny, was added in the sixteenth century and, according to legend, is a 'Devil's door'. It was believed the Devil stalked newborn children, continually hovering over them, waiting for a good moment when the child was unattended to claim their soul. For this reason, baptisms in the past were done as soon after birth as possible. Witnessing a baptism take place, the Devil's vigil would come to a rapid end and he'd be expelled by the regenerative power of

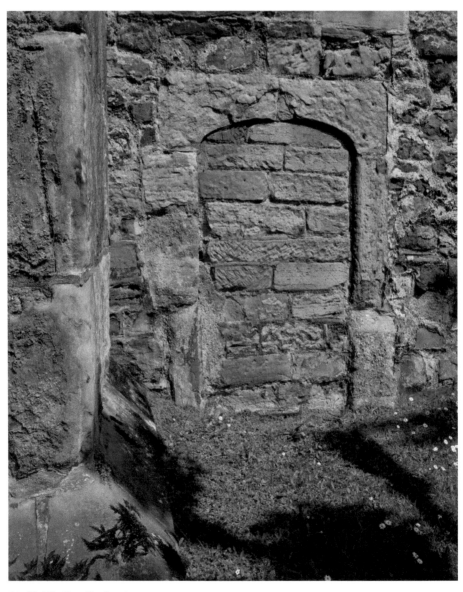

Lindfield's 'Devil's door'.

the ceremony. At Lindfield, it would be through this door, situated conveniently close to the font, to aid his flight. If there was a more matter-of-fact purpose for the door, it's unknown. Surely it wasn't for people to leave the church following a baptism, as they'd have gone out through the main door. And it isn't as tiny as it seems. It was once a fairly normal-sized door; it's been reduced in height by the gradual rise of the ground around the side of the church.

Rest My Case

A coffin rest stands under the substantial lychgate of Bolney Church and is quite a rare structure now. Local man Edward Huth had the gate built in 1905; there are several memorials to his family inside the church. It's made of oak and the flooring

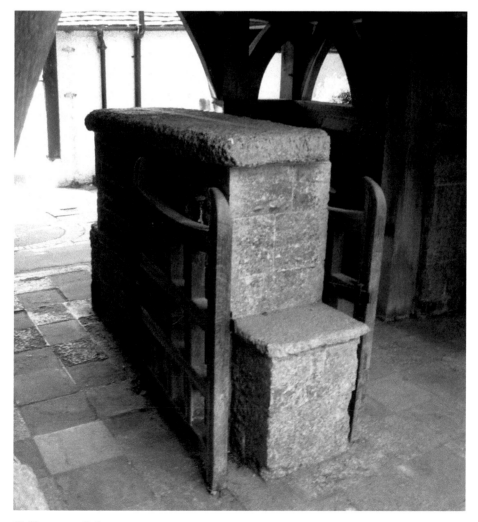

Coffin rest at Bolney.

is made up of Sussex marble tiles into which two millstones are set. There's another similar coffin rest at East Preston's church, again under the lychgate.

They served a number of functions. In the past there was no time limit for funerals (it's usually forty-five minutes today) and if a lengthy service was in progress and another cortège arrived it wouldn't be fitting to just lay the coffin on the ground while everyone waited to get inside the church. Hence these rests, where the coffin could be placed while everyone waited for the previous service to conclude. Sometimes the undertakers would take the coffin from the hearse to the rest, then family members would take it on to the church, the rest facilitating the transfer. Often the first part of the funeral service would take place while the coffin lay on the rest, then continued as it was taken into the church or to the graveside. If it was raining the lychgate would provide cover for the coffin and key mourners as the funeral service commenced.

Long-term Sentence

An anchorite was, essentially, a recluse who sought the shelter of the church. If found suitably worthy, the individual would be 'immured' – that is, walled-up

Anchorite cell at Shoreham.

inside a specially built small cell attached to the main body of the church, with a 'ceremony of enclosure', similar to a burial service. It sounds alarming, but there would usually be several windows to the structure: one facing the altar of the church, so the anchorite could participate in services; another would open onto a parlour, for the supply of provisions; and another would face the outside world. Often, recluses would be women, who might tend a garden outside, make and mend church vestments and act as a kind of caretaker between services. Cells were 'one-offs' and only used by one anchorite. It was usually expected that the person was 'enclosed' for the rest of their lives, and when they died, if there was no door, the cell would have to be demolished to get them out, their burial often taking place where the cell had stood, beneath the floor.

St Julian's Church, in the parish of Kingston Buci, Shoreham, built in 1050, has the remains of such a cell. Life would have been spartan to say the least, the north side of the church chosen so the anchorite would 'deliberately forego the sunshine with the rest of nature's gifts'. The small door suggests the anchorite would be allowed to pass through into the church, and the small window enabled them to take part in services. It's thought that over the church's long history, there were several anchorites; the last one was probably female, known as an anchoress, who had a small garden in the churchyard, which she tended. By the sixteenth century the number of church anchorites severely declined, mainly in the wake of the Reformation.

Another cell at Lewes.

Another cell, of around 1250, is at St Anne's Church, Lewes, and wasn't discovered until 1927. It was made at the bequest of Richard Wych, Bishop of Chichester (1245–53, canonised in 1262) and was uncovered when a new vestry was being built. When the female who occupied it died, she was indeed buried under the floor of the cell as bones were revealed during the building work, and subsequently reinterred in the chancel. Only the window of the cell survives today.

Hall of Brotherhood

When thinking of the Reformation (1536–41), the time Henry VIII disbanded the monasteries to form the Church of England, it's the large, well-known ones that first come to mind. In Sussex places like Michelham Priory, Battle Abbey and Lewes Priory were closed and sold off, or sometimes given over to Henry's supporters. But other much smaller local convents and friaries were shut down too, and the

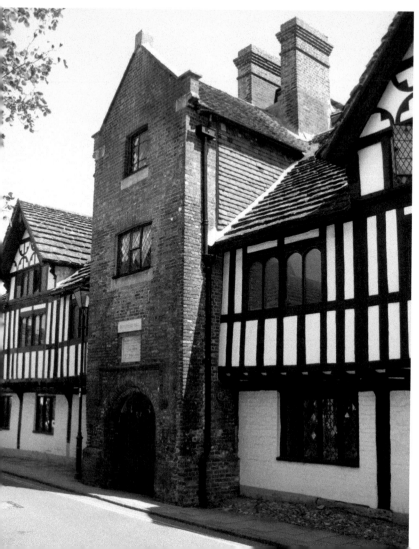

The Brotherhood Hall in Steyning's Church Street.

Brotherhood Hall of the Fraternity of the Holy Trinity, at Steyning, was one of them. Their premises, in Church Street, were originally a merchant guildhall utilised by the cloth industry (timbers inside have been dated to around 1450), but a lease bearing the date 1539 shows it occupied by the brotherhood, operating as a charity overseen by several trustees, including Sir Richard Sherely of nearby Wiston.

The Dissolution of the Monasteries saw the brotherhood losing their headquarters and it was duly sold off, with Henry's coffers benefiting by £535 9s 1d. The building passed to a succession of wealthy families, eventually becoming a small school for boys in 1584. Thirty years later, in 1614, during the reign of James I, the building became Steyning's well-known grammar school, founded by a wealthy local merchant named William Holland. Enlarged numerous times over the years, the school would become a co-educational comprehensive in 1968 when it merged with Steyning Secondary Modern School, situated in nearby Shooting Field. The Church Street site, including the old Brotherhood Hall, became the Lower School, which is still in use today.

Sad Steps

Some grim remains have only recently come to public view outside the Town Hall at Lewes. Leading down from pavement level, a set of old steps can be seen through a strengthened glass cover. These lead to a large underground cellar that

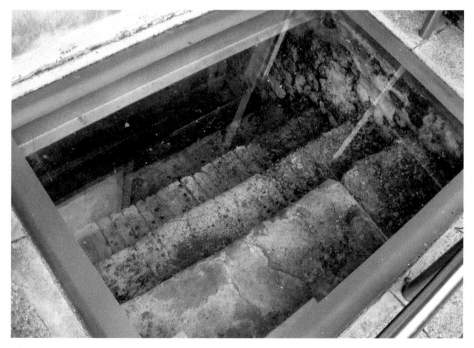

The martyrs' steps at Lewes.

was once part of the Star Inn, which originally stood on the site. It was outside this inn between 1555 and 1557 that seventeen Protestants were burnt at the stake at the order of Queen Mary, in her attempt to covert Britain back to Catholicism. The cellar was where a number of them were imprisoned, and they would have gone up the steps to face their deaths. Allowing a view of these steps was the idea of councillor and historian Mike Chartier. In 2016, the façade of the Town Hall was renovated and he thought 'opening up' the steps as part of the work would be of interest, especially as they linked to the town's annual November firework night celebrations. The site of the burnings roughly corresponds to where the war memorial stands at the top of School Hill.

Cubist Trio

From some very old buildings to a trio of much more modern ones. In Saltdean's Wicklands Avenue three of the most bizarre houses ever built in Sussex used to stand, constructed in an exceptionally modernist style during 1934. They were designed by the architectural firm of Connell and Ward, their look strongly influenced by a Le Corbusier development known as La Cite Fruges, completed in 1926 in Pessac, Normandy. A Mr Snow paid £1,600 for all three properties, naming them 'Unique' (left), 'One Other' (in the background) and 'Foursquare' (right). The brief to the architects was for the trio of buildings to create 'a seaside atmosphere'. They became well known and much photographed for their cubist look, particularly by students of architecture. One Other burnt down in 1954, while Foursquare was demolished and replaced by a more conventional house in 1994. Unique (aptly named) survives.

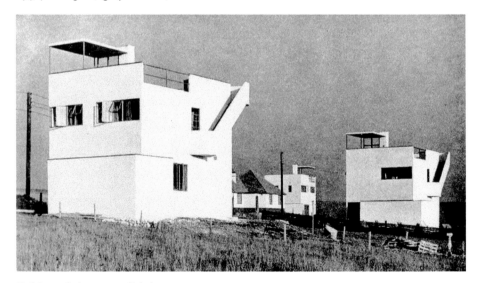

Cubist-style houses at Saltdean.

Lasting Celebration

There is a huge, V-shaped plantation of trees on the Downs between Westmeston and Plumpton, created in 1887 to commemorate the Golden Jubilee of Queen Victoria. It's still in place, looking extremely impressive at any time of year. It's located immediately opposite the road leading to Streat. The cost of the project – just £38 – was borne by landowner Henry Charles Lane of Middleton, and the trees were planted by Tom Packham of Oakwood Farm, Streat, and his father, who had the idea for the project. Originally there was to be a huge 'R' next to the 'V' (for Regina) and a crown of trees above, but apparently the lay of the land prevented these being included. The outside measurement of each 'arm' was 165 yards, with the inside measurement at 104 yards. As for their width, it was decided that 'a time-honoured' measurement should be used, the 20th of a quarter of a mile; in other words, 22 yards – the length of a cricket pitch.

A total of 3,060 trees were incorporated into the design – 1,200 Scotch pine, 800 spruce, 400 larch, 400 beech, 200 sycamore, 20 lime and 40 Australian pine. Doubtless this number has been thinned out over the years. The trees were planted very close to each other 'so they should mutually shelter themselves from strong winds'. And this is precisely what happened, and the 'V' continues to stand nearly a century and a half after being planted.

V-shaped plantation opposite the road to Streat.

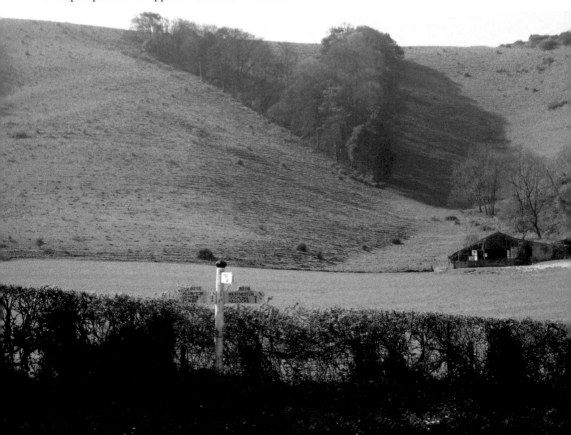

Dance of Death

A single tree, standing just beyond the northern end of Worthing's Broadwater Green, by the busy A27 roundabout, has a spooky story attached to it. This was described by Charlotte Latham in her publication *West Sussex Superstitions Lingering in 1868*:

> There stood, and may still stand, upon the downs, close to Broadwater, an oak-tree, that I used, in days gone by, to gaze at with an uncomfortable and suspicious look from having heard that always on Midsummer Eve, just at midnight, a number of skeletons started up from its roots, and, joining hands, danced round it till cock-crow, and then as suddenly sank down again. My informant knew several persons who had actually seen this dance of death, but one young man in particular was named to me, who, having been detained at Findon by business till very late, and forgetting that it was Midsummer Eve, had been frightened (no difficult matter we may suspect) out of his very senses by seeing the dead men capering to the rattling of their own bones.

This is an example of ancient trees being thought of as portals for spirits to manifest themselves in our world – once a common belief and still lingering until fairly recently in several parts of Europe. On the eve of Midsummer Day, the longest day of the year, people would go out in pairs, afraid of a ghostly

Broadwater's Midsummer tree.

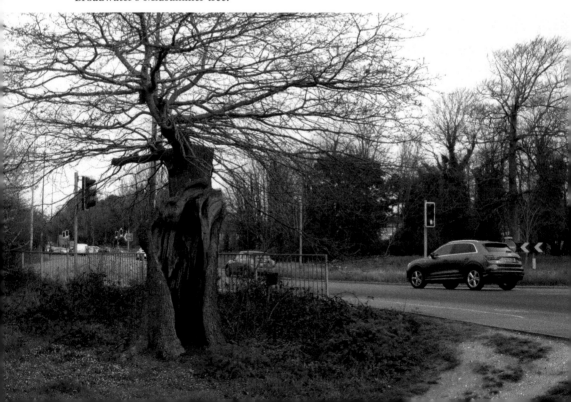

encounter as it was the evening when spirits were at their most active and seeking to materialise. Later, Halloween was thought the more opportune time.

The tree was going to be removed by the Highways Agency in 2006, as it was thought to be dying, but a campaign led by Worthing historian Chris Hare saw not only a reprieve, but a notice installed alongside the tree telling the story. It was extensively pruned, however, but the one large branch remaining continues to thresh, full of life, each spring.

Go With the Flow

A powerful spring of water gushes out of a bank at Fulking, close to the Shepherd and Dog pub. In the past Fulking was a location for sheep washing, and the spring was a handy provider of the water used for it. Sheep pens were set up close by (there was a natural dip in the road opposite the spring that was ideal for this) and the

The Fulking spring.

sheep would be herded through and washed prior to shearing. Around 1886, water from the spring was used to provide the village with its own piped water supply. Two men are credited with devising the scheme. Surprisingly, one was the famous artist, writer and socialist John Ruskin, who was an occasional visitor to the area, and the other was Henry Willett from Brighton. The system they came up with supplied the village with piped water until a mains system was installed in the 1950s. The kiosk-like structure near the spring is a pump house, part of the old system.

Rye's Reservoir

Another curiosity connected with plumbing matters is this peculiar building in the churchyard of St Mary's at Rye. It's a masterpiece of bricklaying skills, but what's it for? In 1733, the mayor and ruling body of Rye sought permission to improve

Reservoir at Rye.

the water supply to the houses high up on the hill of the town, and allocated £600 towards the cost. And 7s was paid to the vicar of Rye, Edward Wilson, for 'damage to churchyard by digging reservoir, if he will receive it'.

So Rye gained this new reservoir, completed in 1735. Its 20,000-gallon capacity was fed from an underground source – some 80 feet below – by a horse-powered pump through a 2-inch-diameter wooden (elm) pipe. The reservoir interior, like a massive bowl, is actually 3 feet below ground level, with water held to a depth of 8 feet. The townspeople received their supplies through a network of pipes and channels and there was a handpump to one side (still there) for a quick bucketful. The tower part, some 10 feet in height, goes right down inside the cistern and acts as a support for the roof of it. It remains probably the quirkiest piece of plumbing in all of Sussex.

Deep, Deeper, Deepest

Sussex seems to have everything, even the deepest hand-dug well in the world. It stands, still in water, just outside the entrance to the Nuffield Hospital at Woodingdean, on the outskirts of Brighton. In the late 1850s, a large workhouse, later to become Brighton General Hospital, was built and an annex in the form of an industrial school for juveniles was established 2 miles away to the north.

Woodingdean's well.

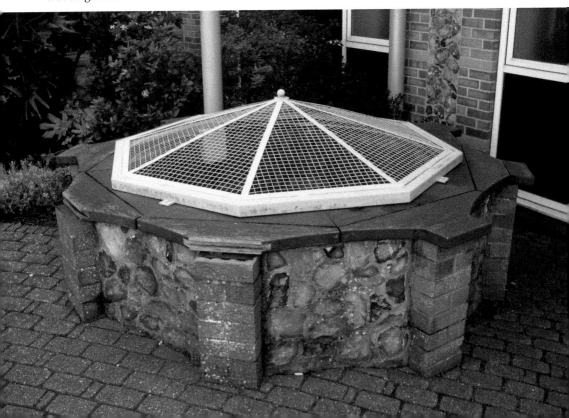

However, the cost of pumping a water supply to this building proved prohibitive, leading to work on a well being dug. Construction started in 1858, but following months of manual labour no source was reached, and the joke went round that the well was 'Brighton's great bore'. Eventually, in March 1862, after four years of digging, water was finally reached. The depth of the well was 390 metres (1,285 feet), a world record, with over half the shaft below sea level. It served the workhouse building for a number of years before piped water came on supply. The building became a conventional school, which in turn was replaced by today's Nuffield Hospital. The comparison usually made is that the well's awesome depth is greater than the height of the Empire State Building, which is a mere 381 metres (1,250 feet.).

Crossing the Bar

Every Sussex inhabitant knows of the unique display of restored historic buildings at Singleton Open Air Museum, near Chichester, which opened in 1965. As well as some fifty houses and other buildings, a great many more modest exhibits are assembled, including the toll house seen here, typical of the many set up in the eighteenth and nineteenth centuries across the county. A gate would straddle the road opposite the toll house and travellers had to pay to access the road, with the money going towards its upkeep. The toll house on show at Singleton dates

Toll house and gate, Singleton Museum.

from 1807 and comes from Beeding (the actual gate is a replica). Outside is a board bearing a list of tolls for various vehicles, animals and commodities. This comes from Northchapel, near Petworth. Most turnpike arrangements came to an end in the 1860s and 1870s. The very last public road to continue under the turnpike system ran between Horsham, Steyning and Old Shoreham, where the final tolls were taken in November 1885.

Home Is Where the Hut Is

Another exhibit at the Weald and Downland Open Air Museum is a shepherd's hut, more caravan than building and once a common sight across Sussex.

Here, a century ago, from November through to March, a shepherd would live permanently with his flock, sleeping out with them – 'on call' day and night. His bed might have consisted of just a few sacks spread out on some trusses of hay or straw, but this hut, with its little stove glowing, would have been delightfully snug and warm – doubly so on a wintry night with wind and rain outside. The shepherd would go out every half hour or so and come back with new arrivals, to be dried

Shepherd's hut on show at Singleton.

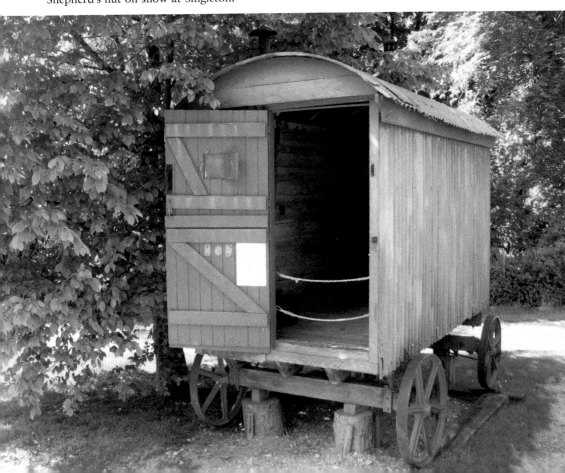

and warmed by the heat of the stove. Up to three other men might have assisted him, depending on the size of the flock. Dominoes were played during quieter moments, with mouth organs, tin whistles or concertinas accompanying songs and rounds.

Lambing was long and arduous work and there was always a sense of relief when it was over. Then would follow stamping the new lambs with their owner's initials and tying the tails so they fell off. These would be collected up and skinned (a tricky process apparently) and for a few days lamb's-tail stew or soup would be on the dinner table of every sheep farm across Sussex.

Toll Survivor

A toll house still standing at its original location can be seen on the A273, at Kingston, near Lewes, and there's a grim story connected to it. It's said to be where a woman known as Nan Kemp committed suicide in the early 1700s. A letter to the *Sussex County Magazine* in 1930 from L. Kennett-Bull of Patcham, gave the following details:

Tollbooth off the A273, near Kingston.

My father, the retired Patcham miller, formerly of Lewes windmill, tells me he has seen the small square stone which marks her grave at Kingston crossroads. The story goes that she murdered her infant, tried to burn it, and only succeeded in partly doing so. She then committed suicide in that small round dwelling that is to be seen this day at the bottom of Kingston Lane, on the main road to Lewes. This happened at the beginning of the 18th century when she was toll-keeper there. My father was told this at Lewes over 40 years ago.

A slightly different version of this story states that she put the dead child into a pie for her husband's supper. The stone marking Nan Kemp's grave seems to have been lost or covered over in the intervening years. A 'Kemp's Cottage' used to exist in the village, but none of the properties today bear this name.

Curiosity Killed the Cats?

Equally grim are the remains of two mummified cats, which catch the eye as soon as you enter the ancient (Elizabethan) Stag Inn in All Saints Street, Hastings. They were discovered in one of the building's chimneys during restoration work in the nineteenth century. A simple explanation is that sometime in the distant past the cats crawled up the chimney, got stuck and died, with the 'smoking' effect from any number of subsequent fires preserving the bodies until they were discovered at a much later date. Or, more sinisterly, they may have been deliberately 'sacrificed' and placed in some alcove in the chimney breast to protect the property against

Mummified cats at Hastings.

evil spirits, cats always being considered symbolic of good luck. With other instances of dead animals being found preserved and hidden away in buildings in other parts of Sussex, the second explanation is probably all too true.

Titanic Memorials

On the bandstand at Eastbourne is a memorial to one of the orchestra players who died in the *Titanic* disaster of April 1912 – John Wesley Woodward.

The following appeared in the *Eastbourne Gazette* the next month:

> While the horror of the Titanic disaster is still fresh in the public mind, and the nation is contributing with an almost unexampled generosity to funds for the survivors and the families of the crew, would it not be as well to give a little thought to those who did not survive? This question finds some response in the feeling which has been expressed in several quarters that a memorial should be erected in Eastbourne to Mr. J. Wesley Woodward, a member of that heroic orchestra, who went down with the ship. Such would be a fitting tribute to a gallant Eastbourne musician, and at the same time perpetuate the memory of the many other heroic deeds performed by the other brave men who perished on that occasion.
>
> A memorial to Mr. Wesley Woodward, who was so well known and so deservedly popular for so long a time in the town, would, we feel sure, be

Eastbourne's *Titanic* memorial.

welcomed by all residents, musical and non-musical alike, to whom heroism and devotion to duty appeal as qualities deserving of honour.

The memorial should preferably be placed either on the Sea front or in the vicinity of the Devonshire Park; and the sculpture should be of a graceful and artistic character, symbolical of music, and above all with no funeral features about it.

A number of Sussex people were on board the *Titanic*:

First-class Passengers
Elsie Bowerman, aged twenty-two, and her mother Edith, aged forty-eight, from St Leonards on Sea. Both survived the sinking. Elsie would become a well-known suffragette and barrister and live to the age of eighty-three; she died in 1973 and is buried at Hastings.

Second Class
David Reeves, aged thirty-six, a carpenter from Slinfold. He died.

Third Class
The Ford family from Rotherford: Margaret, aged forty-eight (a poultry farmer); Arthur, aged twenty-two; Dollina, aged twenty; Edward, aged eighteen; William, aged sixteen; and Robina, aged just seven. All died.

Marian Meanwell, aged sixty-three, a milliner from Eastbourne. Died.

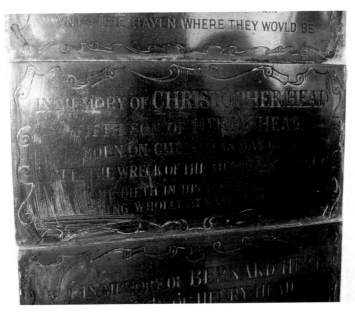

Memorial to *Titanic* victim Christopher Head.

William Morely, aged thirty-four, another carpenter, from Petworth. Died.

Charles Shorney, aged twenty-two, a valet from Heron's Ghyll. Also died.

One other local person associated with the disaster was Christopher Head, aged forty-two, given in the passenger list (first class) as living in Chelsea. The Heads were a Shoreham family and a plaque to several of them, including Christopher (born on Christmas Day in 1869), is on the wall of St Nicolas' Church in the town. Sadly, he too was another victim of the sinking, although it remains a mystery as to why he was actually on the *Titanic*.

Blowing in the Wind

Windmills were once in abundance in Sussex and although many have been demolished or stand abandoned, a number have been preserved, with a few restored to working order. Halnaker Windmill, standing 127 metres above sea level on a hill above Chichester, is one of several windmills in the care of West Sussex County Council. In 1958 it was decided to preserve one example of each of the three kinds of windmill in the county: a tower mill, a post mill and a smock mill. Halnaker Mill was the tower mill they chose; it's built of brick and only the 'cap' moves round, along with the sweeps. It's said there's been a windmill on this site from 1540, but the present structure dates from 1740. It ground corn for the poor of the district and was worked until damaged by a lightning strike in 1905. Today it stands devoid of any internal workings.

The preserved post mill, which the council look after, is at High Salvington. The smock mill is the one standing at Shipley.

Shipley Windmill has a number of claims to fame. It was the last smock windmill to be built in Sussex, going up in 1879, but then only used regularly until 1922.

For many years it was owned by the well-known Sussex writer and historian Hillaire Belloc (1906–53), one of the most prolific writers of his generation. His *Cautionary Tales*, where dreadful things happen to naughty children (remember Jim, who ran away from his nurse and was eaten by a lion?), remain popular today. A collection of his poetry, published in 1923, featured several Sussex poems, 'Ha'nacker Mill', 'Lift up Your Hearts in Gumber', 'Duncton Hill' and the well-known 'The South Country'. The windmill was used as a location for the popular *Jonathan Creek* TV series starring Alan Davies and Caroline Quentin. Twenty-two episodes of the series were filmed at the mill. Despite a visitor's centre opening in 2001 and various grants being awarded to maintain the mill, it's now in a somewhat dilapidated condition and closed to the public.

Oldland Windmill stands above Hassocks, directly across the valley from the famous Jack and Jill windmills. Built in 1703, it operated for over 200 years,

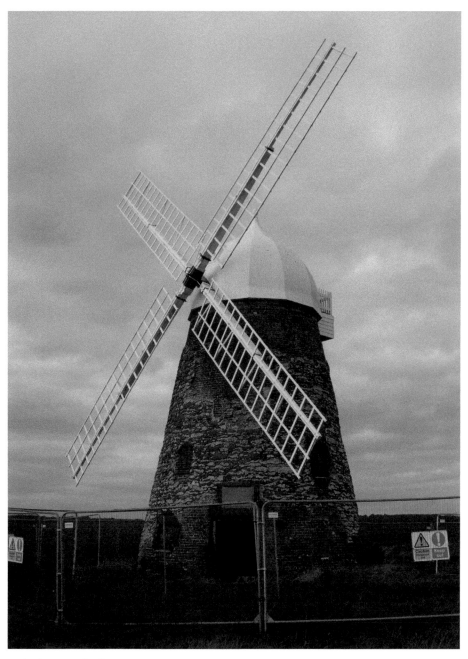

Halnaker Windmill.

serving the milling needs of the local community, but was abandoned in 1912 and left to the elements. Restoration by a dedicated band of enthusiasts began in the 1980s and new sweeps (sails) were completed in 2007. In October the following year flour poured from the millstones for the first time in a century.

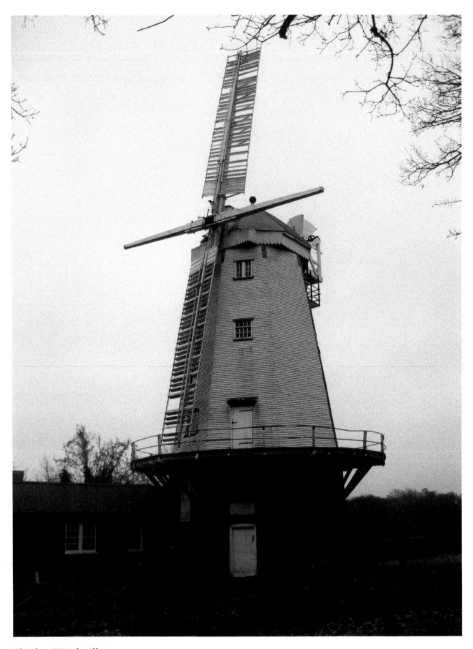

Shipley Windmill.

There are open days at Oldland throughout the year, where the mill is up and running and a small fair is held in the grounds to raise funds for further restoration. Details of these visitor days can easily be found online.

Another impressive windmill that can be visited is at West Blatchington, Hove, once part of a farm on the site. The mill dates from around 1820 and is unusual

Oldland Windmill.

in being constructed on a tall flint-and-brick tower, said to be a dovecote, with barns on three sides. It's another smock mill, but unique in being six sided; smock mills usually have eight sides. Both flour and animal foods were produced for some eighty years before milling stopped in 1897, then in 1936 the south barn was lost in a fire. After standing abandoned for many years, it was opened to

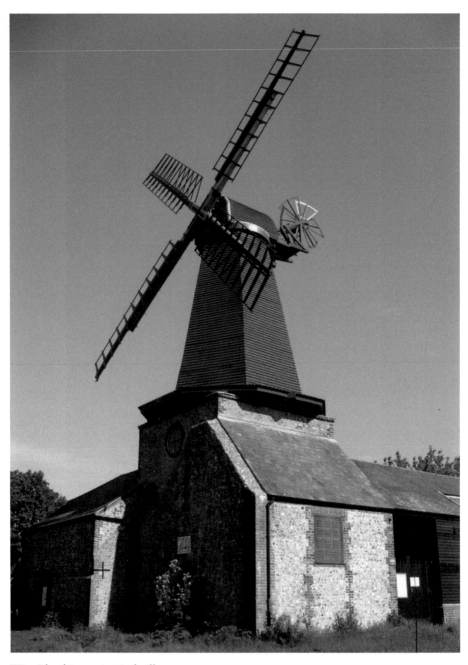

West Blatchington's windmill.

the public in 1979 after extensive restoration work by volunteers and input from the local council. Beneath the mill today is a fine collection of farming, milling and agricultural equipment. Again, a website gives details of opening times and arrangements.

Any Old Iron

The manufacture of iron was once a major source of work and wealth in Sussex. It was the oldest and longest running industry in the county, having gone on for some 2,000 years, starting well before Roman times and lasting into the late Georgian period. Outcrops of clay ironstone, the key ingredient, occurred in large quantities in the High Weald, an area stretching east of Horsham to below Tunbridge Wells, then south to Hastings. With large forests such as Tilgate, St Leonard's and Ashdown providing charcoal, vital for the heating and extraction process, and water, for cooling, coming from dammed up lakes and streams, many of which still exist (the well-known 'Hammer Ponds' of Sussex), it's not surprising that the industry flourished so long; everything needed was at hand and in large quantities.

The earliest, rudimentary forms of smelting took place in small furnaces known as bloomeries, usually created on sites where the ironstone outcrops were near the surface. This went on for centuries, until eventually large blast furnaces were introduced at the end of the fifteenth century, leading to far greater output and the creation of cast iron. In 1543, the first cast-iron cannon in England was made by Peter Baude and Ralph Hogge, at their Buxted works.

The Weald became the largest producer of iron in the whole of Britain, producing all manner of products, particularly cannons and shot for the military. Other associated industries became established, including several gunpowder factories. Firebacks – decorative iron sheets placed at the back of fireplaces to reflect the heat out into a room – were produced in great quantities, and many

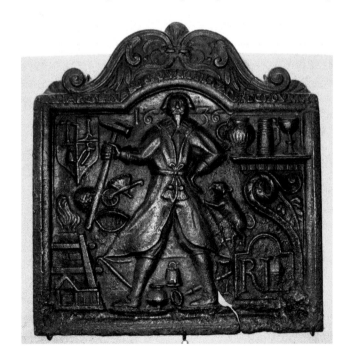

Richard Lenard, ironmaster of Brede, depicted on a fireback made at his works.

large Sussex houses still have examples on show. However, from around 1640 competition and cheaper production elsewhere saw the industry gradually decline and the last working Sussex furnace, at Ashburnham, ended its days in 1813.

In the Anne of Cleves House Museum at Lewes there's an outstanding display of items relating to the Sussex iron industry, including a recreation of one of the massive trip hammers used for shaping the iron, also operated using water power. Pride of place though goes to an elaborate fireback of 1636, showing a proud Richard Lenard, the ironmaster of works at Brede, surrounded by items relating to his business.

Hold Your Nose Time

At Henfield, near the church, is a small park with the unexpected name of 'Pinchnose Green', which relates to a tannery that used to occupy the site in the seventeenth century. Tanning was the process by which leather was produced from the skins and hides of animals, an extremely smelly process that often saw tanning yards located on the outskirts of villages and towns. Then, methods of tanning involved using urine and animal faeces to make the skin more durable and less liable to decomposition, which combined with the smell of decaying flesh still on the skins, produced the noxious odour. All that survives today at Pinchnose Green is Tannery Barn (now a private house), where the more delicate leather was produced, such as for gloves, and a small workshop, restored in 1933. There would have been a well at the works, located close to the pond in the park and supplied by the same spring.

Pinchnose Green, Henfield.

Tower of Strength

In addition to Sussex's industrial past is its military past. Remains of defences can be found along the whole length of the Sussex coastline, particularly near rivers, such as Shoreham Fort, at the mouth of the Adur, mentioned in the 'Ruins' section of this book.

This old print shows the destruction of a Martello tower in 1861. Seventy-four of these defensive towers were built from Folkestone and Seaford during the Napoleonic Wars. After the battles at Trafalgar (1805) and Waterloo (1815) the French threat was over and the towers largely became redundant. The caption that accompanied the print seen here stated:

In August 1861, Martello Tower no. 71, about half a mile from the redoubt at Eastbourne, was selected as a target for testing the new guns invented by Sir W. Armstrong. The guns used were a 40-pounder, an 80-pounder and a 100-pounder. The projectiles were partly solid shot and partly percussion shells, and were fired at a range of 1032 yds. The walls of the tower, built of solid brick, were 7ft 3in on the land side and 9ft on the side facing the sea.

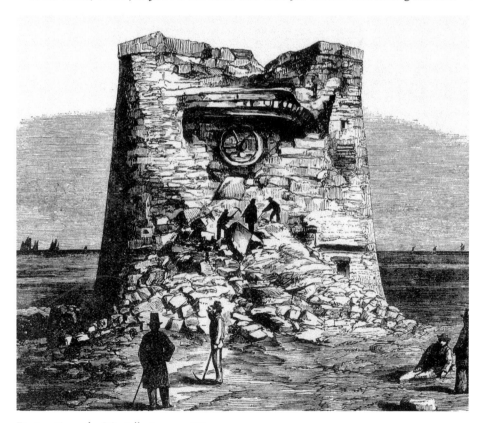

Destruction of a Martello tower, 1861.

In all 170 shot and shell were fired, but the tower was only partly demolished. The experiment was watched by the Duke of Cambridge and a number of artillery officers.

Today, only ten of these old towers survive in Sussex; six stand between Eastbourne and Pevensey.

Tanked Up

In undergrowth south of the South Downs Way and the car park between Springhead Hill and Kithurst Hill, near Storrington, used to lie the rusting remains of a Mk II Churchill tank. During the Second World War the area above Storrington, Cootham and Parham House was used by the military for training. The tank was one of many due to be used for the Dieppe raid of August 1942, but developed mechanical problems and was left behind. It was never repaired, so was used for target practice and after the war, when the area was cleared of pill boxes and anti-tank traps, an attempt was made to remove the tank. This proved an impossible task, with no suitable access road for the massive 'tow away' vehicle that would have to be used, plus soft ground conditions, so the tank was just rolled into a nearby bomb crater and spent the next fifty years buried upside down. In 1993, men from the Royal Electrical and Mechanical Engineers uncovered the tank and managed to turn it over and drag it to the side of a field, where it was left to just rust away.

Abandoned tank above Storrington.

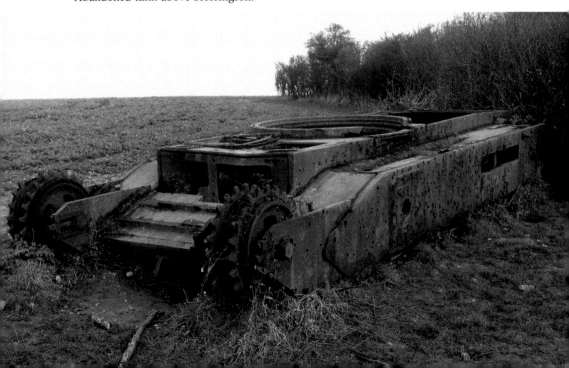

The tank was unexpectedly removed in the summer of 2019, which caused something of a public outcry, but this was so it could be restored with the intention of being displayed in a museum in France, commemorating the D-Day landings.

A Spot of Bother on the Beach

In April 1919, a few months after the end of the First World War, a German submarine (a U-118) was washed up on the beach at Hastings, and, as can be imagined, caused quite a stir. It had been surrendered by German forces in February, but broke free while being towed to France and after several weeks floating around went aground at Hastings, opposite the Queen's Hotel. Thousands flocked to the seafront to see the vessel and in time the town council imposed a charge for anyone climbing on board. The proceeds went towards a fund for events to welcome home the town's troops, planned for later that year.

In time, the U-boat became an eyesore and 'in the way', so the order was given to break it up for scrap. However, souvenir hunters quickly moved in and took parts away. The town itself decided to keep the submarine's gun, but it got buried in the shingle by wave action. Although recovered in 1921, the gun was disposed of despite calls for it to be displayed on a plinth as a permanent reminder of the event.

The submarine had seen little action. It was built in the Vulcan shipyard, Hamburg, and was launched in February 1918. Under the command of Herbert Strohwasser, it managed to sink two ships while on its only patrol before it surrendered, exactly one year after it was launched.

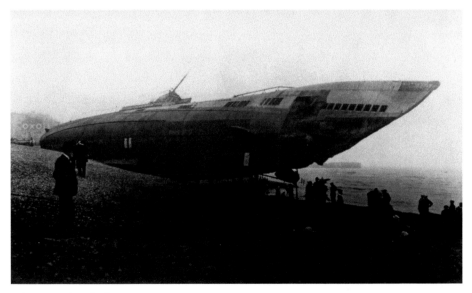

Submarine beached at Hastings, 1919.

Unusual War Memorials

Every year, on the closest Sunday to 11 November, Remembrance Day services are held across Sussex, honouring those who lost their lives in both world wars and other subsequent conflicts.

War memorials in the county take on all manner of shapes and sizes and a number of highly unusual ones, some completely unique, can be found.

At the gate of St Mary's Church at Sullington, near Storrington, the names of the casualties of the First World War are inscribed on an upright agricultural roller, cemented into a plinth and topped by a lantern. It bears the inscription, 'Let Your Light Shine Before Men'. Four names are given along with a dedication to the thirty-five crew members of a submarine, the E 24, one of whom came from Sullington. The vessel was based at Harwich and struck a surface mine in March 1916, off Hegioland, in the North Sea.

The memorial at Burwash also bears a lantern, which is lit on the anniversary of the death of every individual recorded on it, a ceremony considered unique to any war monument. One name everyone looks for is John Kipling, son of poet Rudyard Kipling, given as missing following the Battle of Loos; his death remained

The war memorial at Sullington.

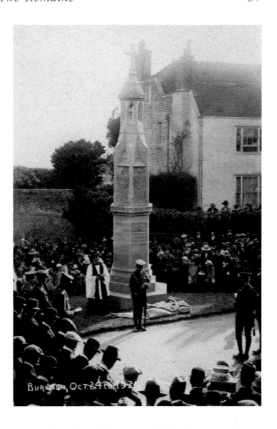

Unveiling the Burwash lantern memorial.

unconfirmed for three years. In 1917, Rudyard Kipling joined the Imperial War Graves Commission and composed several of the epitaphs used on its memorials, including 'Their Name Liveth for Evermore' (which is on the Burwash one) and 'A Soldier of the Great War known unto God'.

At East Wittering, there are, surprisingly, no names at all on the monument commemorating the First World War. All who went off to fight survived, returning safely home and making the place one of the few 'Thankful Villages' in Britain. In fact, East Wittering is the only town or village in the whole of Sussex where no lives were lost between 1914 and 1918, so the memorial is completely unique in the county.

In the field just across from the well-known coastguard cottages on the cliffs overlooking the estuary at Cuckmere Haven, is a plaque on a stone cairn.

It tells a tragic and largely unknown story from the Second World War: 'This plaque commemorates the soldiers who died in this area and specifically in this field during World War II. Their numbers are unknown but their memory lives on.'

Corporal Leslie Edwards (1920–2004), a local man who served in the area and laid poppies at the spot every Remembrance Day until he died, recalled the incident:

I will never forget the day in 1940 when a Canadian company came to Cuckmere and pitched their tents in this field. I was stationed here and

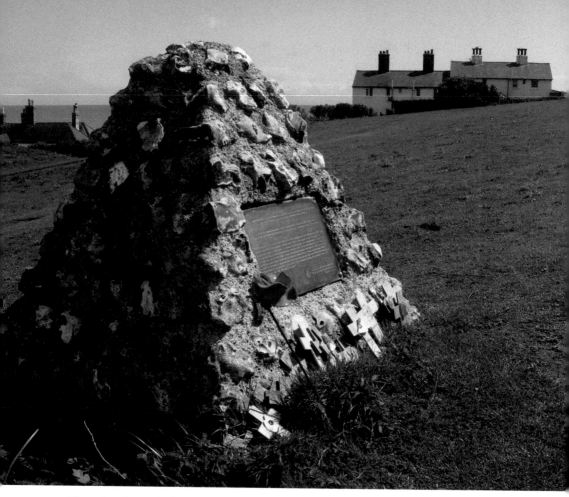

The cairn above Cuckmere Haven.

knew that bombers regularly used this valley for navigational purposes. I tried to tell the commanding officer but he was not interested in what I had to say. Two mornings later the Messerschmitts arrived. Just as the sun was rising they came skimming over the water and up the valley. Around Alfriston they banked hard and came back bearing down on the tents and opened fire. Steam, soil and grass rose in front of them as bullets and bombs entered the ground. All the young men in the marquees and bell tents were killed. The commanding officer who was shaving at the time in the middle coastguard cottage, died instantly when a shell went through the wall that held his mirror.

Fifty-five old boys of Lewes County Grammar School (now known as the Priory School) died on active service in the Second World War. Their monument is the whole of the chapel in the school grounds, built and dedicated in 1960 after years of fundraising. The chapel is generally acknowledged to be the only officially sanctioned war memorial in any state school in Britain. On the lintel of the main

door are carved the three words '*Dare Nec Computare*' ('To give and not to count the cost') and accompanying the list of names is the epitaph 'Seek for their resting place not in the earth but in the hearts of men'.

Another highly unusual memorial stands on the Downs above Patcham, Brighton, known as the Chattri, commemorating Indian casualties of the First World War. A young Prince of Wales, later Edward VIII, performed its inauguration in February 1921. This was the site where fifty-three Hindu and Sikh soldiers who had died while hospitalised at the Royal Pavilion were cremated with full ritual ceremony. Three cremation slabs, known as ghats, were used and afterwards the ashes of the men were scattered onto the sea. The word Chattri means 'umbrella', which is fitting as the design of the memorial was seen as protecting the memory of the dead.

India's 'men of the empire' were immediately called on to fight in the war, being substantial in number and already fully trained. A whole string of temporary hospitals were established along the south coast, from Dover to the New Forest area, to take all nationalities of wounded, sent by train to Britain, via coastal ports. The Royal Pavilion was the most unique of these, becoming a hospital at the personal suggestion of George V.

The war memorial in the grounds of the gardens opposite Beach House, Worthing, is unexpected, to say the least, and probably the only one of its kind in Britain. It's dedicated to the carrier pigeons of the Second World War, which

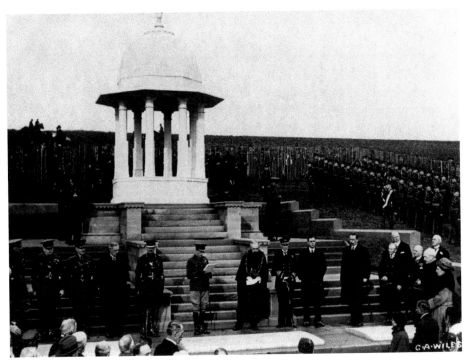

Unveiling the Chattri, Brighton, 1921.

were used to transfer secret messages, explosives or spy cameras back and forth from enemy locations, often flying huge distances, sometimes through Europe then across the Channel. A local sculptor, Leslie Sharp, created the memorial, which was unveiled in July 1951 by the Duke and Duchess of Hamilton and Brandon. Sadly, two stone pigeons, part of the original design, were subsequently stolen.

One stone bears the words, 'In memory of Warrior Birds who gave their lives on active service 1939–45 and for the use and pleasure of living birds.' The other reads, 'A bird of the air shall carry the voice and that which hath wings shall tell the matter. This memorial is presented by Nancy Price and members of the Player's Theatre, London.' (The line 'A bird of the air shall carry the voice…' is from Ecclesiastes, 10:12.) Nancy Price was an actor with the Player's Theatre, a keen birdwatcher and a resident of Worthing in her later life.

Such was the success of using homing pigeons, MI5 was still apprehensive about enemy use of them following the war. In order to prepare countermeasures, they arranged for a hundred birds to be looked after by a civilian pigeon fancier right up to 1950.

Memorial to 'Warrior Birds' of the Second World War.

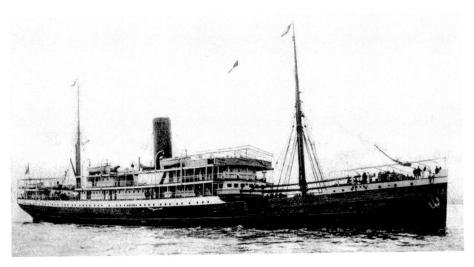

RMS *Mendi*.

But the most bizarre memorial of them all, until you know the story, has to be the one in Newtimber Church dedicated to St John the Evangelist, which is actually an inscribed branch of a tree from South Africa, 5 feet in length. This commemorates the sinking of a supply ship in the English Channel in February 1917, the RMS *Mendi*, with a loss of nearly 650 men, mostly South Africans. It was in collision with another ship, the SS *Darro*, twice its size, and the sinking has achieved almost legendary status in South African history. Seeing the situation was hopeless, the captain is said to have shot himself and the men allegedly performed a kind of dance of death before the ship went down, stamping in unison on the deck with their bare feet. There doesn't seem to be any Sussex connection with the sinking, but Earl Sidney Buxton, Governor of South Africa at the time, lived in Newtimber Place (his grandson still lives there today) and when a site for a memorial was being finalised Newtimber Church was put forward, along with one in South Africa itself.

But why a tree branch and not something more conventional? A small, inscribed plaque was installed by the church path in August 2001, but the branch was presented to the church in September 2013 by Zwai Hgijma, grandson of one of the men who had died in the sinking, who was in fact a tribal chief named Bokleni. Cut from a Dywabisini tree from Pondoland, the branch was symbolic of the lost men's homeland. The inscription on it reads: 'iAFRIKA iYazi MENDIWWI', which translates to, 'Africa knows about Mendi WWI'. The belief was that a dead person's spirit cannot rest unless their bones are in their native country. As the men's bones were on the seabed and irretrievable, an identical branch was dropped down on the actual wreck in the belief the dead men's spirits would then be able to bond with part of their homeland and thereby find rest.

In reality, every war memorial is unique, even the more conventional plaques, crosses and statues. They represent a community's chosen method of remembrance and the names on a memorial might only appear there, and nowhere else, making

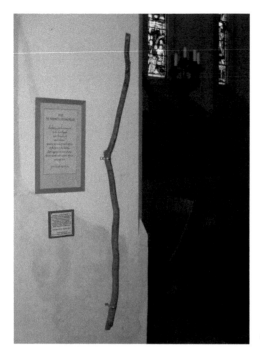

The 'Mendi' branch.

them a vital commemoration of individual sacrifice. For every inscription there is a very human story to be told. They are historical touchstones in the way they link the past to the present and enable people to continually value the sacrifices that were made, and continue to be made, right up to the present day, in conflicts across the world that involve Sussex men and women.

Fallen Idols

We know that ancient civilizations, like the Egyptians, Greeks and Romans, had a belief system in gods who controlled many aspects of their earthly, mortal lives. So the Egyptian Hathor was venerated as goddess of motherhood, the Greek Poseidon was god of the seas and oceans, and the Roman Minerva was goddess of craft and wisdom. Did the ancient Britons have a similar array of gods they believed in, who influenced their affairs? The answer is that they did, and a number of specific ones are known about, most being Romano-Celtic in origin. Belatucadros or Belatucadrus, a god of war, was worshipped mainly in northern Britain, particularly in Cumberland and Westmorland and was similar to the Roman Mars. He's known about from many inscriptions in the vicinity of Hadrian's Wall. There was also Cocidus, goddess of hunting, Nodons, god of healing, and Sulis, goddess of healing waters. This last one is of special interest as the city of Bath is named after her (Aqua Sulis). There were many others, but what isn't clear is how widespread belief in them was and if they were known about in Sussex.

Paganism lasted longer in Sussex than in any other part of Britain. There have been some valiant efforts to equate Sussex place names with sites of possible pagan shrines, mainly using old English words such as *esa* ('of Gods') and *burna* ('a stream' or 'spring'). So somewhere like Easebourne, near Midhurst, could derive from 'Spring of the Gods'. Other old English words like *wig* ('shrine') and *leah* ('wood' or 'clearing') could have named Old Whyly, at East Hoathly. However, none of this is definite, no structures have been found at these locations and elsewhere; nothing that could be positively identified as a pagan 'temple' has ever been excavated. One that caused a flurry of excitement was discovered near Friar's Oak, Hassocks (excavated and reported on by Chris Butler in 2000), where a square 3-metre building was unearthed that was too small for habitation. But nothing conclusive about its use could be deduced. A worthwhile website for those interested in looking further into place names and sites is *Pagan Place Names in Sussex*.

So, what physical evidence of pagan gods is there? There are only a few finds that give a tantalising insight into what may have been going on with ancient worship in the county. The first to be detailed – until very recently – was one of the most extraordinary remains in the whole county.

All Saints' Church in the village of Wiston is a wonderfully mysterious church (Grade I listed), which seems to be hiding from visitors – you can't even see it from the approach path. It's a Saxon-Norman transitional building, with the walls built from a whole variety of different materials including Roman roof tiles and there are three bizarre external arches, where whoever constructed them clearly 'did their own thing'.

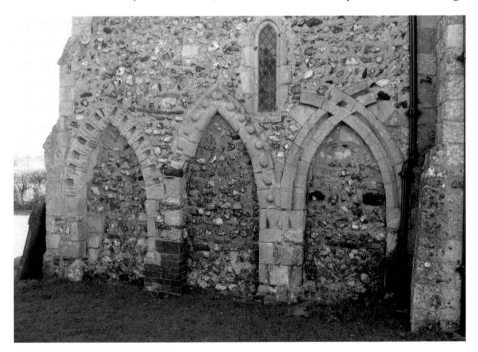

The arches at All Saints, Wiston.

Until recently, the church used to contain a strange carving – unique in the whole of Sussex. This was high up on the left side of the chancel arch, taking the form of what is termed a Sheela-na-gig, essentially an architectural grotesque akin to a gargoyle. It seemed to show a woman (the sex wasn't clear) in the act of exposing herself, or 'flashing' as we would term it now, a bizarre sculpture to have in a church, but obviously an addition to the original arch. In December 2004, it was hacked away, probably with a chisel, by someone on a ladder who must have thought it too pagan or just plain rude to have in a Christian church. At the time the police had a definite suspect, but nothing could be proved. The pieces were left scattered on the church floor – too many of them being tiny chippings, preventing the figure to be restored. The vague outline of where it was can still be made out.

Sheela-na-gig figures have been found across the UK and in many parts of Europe. A large number exist in Ireland, and they adorn churches, occasionally secular buildings, even castles. It's not clear what they stood for or even what the name really means. A depiction of a pagan goddess of fertility, a device to ward off evil, a religious warning to avoid the sins of the flesh – there are several interpretations. The connection with fertility and childbirth is the most popular, many seemingly worn through being touched as kind of lucky charm by expectant mothers, or newlywed couples hoping to start a family. The one at Buncton was certainly well worn in one particular area! It was the only Sheela-na-gig in the county – extremely curious, but now sadly lost forever.

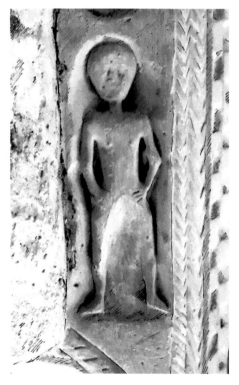

Wiston's Sheela-na-gig.

Another similar kind of remnant of the pre-Christian era, essentially a head and shoulders sculpture, was found in a peat bog, around 11 feet down, near Piltdown. It measured 18 inches in height, 23 inches in width, the face occupying nearly the whole height of the stone. The mouth was 4 inches wide, the eyes 1½ inches in diameter. All these measurements equate with those of a similar carving found in Guernsey. Both heads are thought to represent a god or goddess (of no specific name) who guarded the dead, and would usually be placed by a grave or the doorway of a mausoleum.

Possibly related to pre-Christian worship is a mysterious stone standing in the porch of Steyning's church. For years this was believed to be a pagan device, used ritualistically to ensure a good harvest. Even until fairly recent times, the harvest was a matter of life and death for a community. A good one would bring well-being and prosperity; a bad one, starvation and decay. So rituals and ceremonies to please whoever or whatever controlled the success of the harvest would be performed in earnest, particularly at planting time.

The Steyning stone may have been stood up in a field prior to planting, with rituals performed – chanting, dancing, drumming – to guarantee a bountiful crop.

Right: Ancient stone in Steyning Church.

Below: Guardian of the dead goddess, found at Piltdown.

It was found when a new heating system was being installed in the church in the summer of 1938 and formed part of some steps in the eastern entrance of the church. It appeared just a block of stone until it was turned over, then the carving was discovered.

The stone could have been a simple grave covering. It seems too thick for this, particularly when compared to an old gravestone that's displayed alongside, which is much thinner. The top is weathered but the bottom is not, indicating it stood upright. Also, there has been some speculation as to whether the design carved on the surface resembles an ankh, the key of life, representing water, air and the sun – vital elements of the harvest. This was an Egyptian motif, endlessly adopted and used throughout the ages, and still appearing today on necklaces and amulets. A Christian cross appears in the centre of the design, deeply scored, seemingly a later addition, possibly to negate its pagan origins. Steyning gets its name from 'Stane' ('stone') and 'ing' ('people of'), and there is a legend that when the first Christian church was built at Styening by Cuthman (later canonised as Saint Cuthman), he found them congregating round a stone, involved in some kind of worship, and decided this was the location for his church.

The green man has to be mentioned, although he's not at all unique to Sussex and doesn't seem to be a pagan god. The one pictured here greets customers at Steyning's post office, carved on a beam dating from the 1300s (the carving being a later addition). Vine leaves emanate from his head, which is unusual as normally they're leaves from a tree.

A green man at Steyning.

The green man is steeped in mystery and folklore and, although possibly pagan in origin, the name is comparatively modern; in the past depictions of him were just referred to as foliated heads. But his image is clearly linked to nature, so may well have been considered another deity venerated for securing a good harvest. Celebrating May Day is thought to be Roman in origin, but it has been pointed out that Osiris, the Egyptian god of renewal and resurrection, is depicted with a green face, as he was also god of agriculture, vegetation and fertility. Does the green man originate from him? Actual May Day celebrations obviously come from ancient agricultural rituals, marking the return of spring. The Celts believed the year was divided into two, with May Day the turning point, moving from darkness to light; fire was a key element of their rituals. The setting up of a maypole and dancing round it, intertwining ribbons, was another fertility ritual observed on May Day dating back to medieval times, if not earlier. However, accounts of effigies of the green man, often known as 'Jack in the Green', a large figure made of foliage and greenery (usually with someone inside, making it move and dance), don't go further back than around 1770. Whatever his origins, the green man has transcended his original purpose to become a symbol of modern-day ecological issues. Many vivid depictions of him, both old and new, can be seen at the annual Hastings 'Jack in the Green' celebration, lasting several days, over the May bank holiday weekend. This event began in 1983 as simply an occasion for some morris dancing, but has grown to a three-day festival, which includes the crowning of a May Queen and the ritualistic 'slaughter' of Jack in the Green. This is where Jack's foliage is pulled off, usually as single leaves, and kept by participants as tokens of good luck and prosperity during the oncoming year.

The Relics

Moving on to some of the leftover relics of Sussex. Most are single objects, often just odd bits and pieces or surviving artefacts, but each with a tale to tell. The range here is striking. Some relics, in their simplicity, are poignant, with a very human aspect; others are grim, with a chilling fascination. Many are mysterious and again, the imagination is stirred. When the story behind them is human and touching the gap between past and present somehow seems not so great.

For Whom the Bells Toll

To start with, probably the most mysterious relics in the whole county – if they're still there! Most Sussex people know the story of the lost cathedral at Selsey that crumbled into the sea during a great flood in 1048 and how its bells can still supposedly be heard ringing from the depths, a few hundred yards offshore. E. F. Harrison of Enfield, in a letter to the *Sussex County Magazine* in April 1935, wrote:

The Selsey bells.

Sixty years ago we were standing on that unpretentious promontory known as Selsey Bill talking to the oldest inhabitant about bygone Sussex, when he declared that his great grandfather had told him that, on the occasion of an extra low tide, he had heard the bells of Selsey Cathedral (for the last 850 years submerged in the English Channel) distinctly ringing.

Sussex Rebels

The name Jack Cade rings a bell for many as somehow connected with Sussex, but for what reason exactly? The picture of his memorial stone seen here at Cade Street, near Heathfield, dates from around a century ago. Today it's

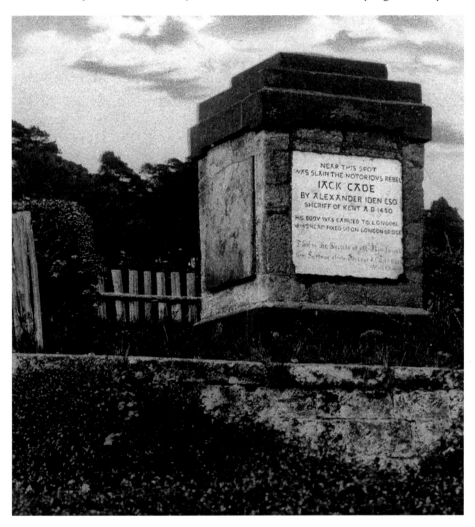

The Cade memorial.

deteriorated a great deal and is almost unreadable, although a metal plaque, added some time in the early 1800s, quotes the old inscription: 'Near this spot was slain the notorious rebel Jack Cade by Alexander Iden, Sheriff of Kent, AD 1450. His body was carried to London and his head fixed upon London Bridge. This is the success of all rebels, and this fortune chanceth ever to traitors.'

The Cade rebellion of 1450 was when a group of some 5,000 armed Kent and Sussex men, under Cade's leadership, marched on London with a whole roster of grievances against the king (Henry VI) and his government. Top of their list was, as ever, high taxation, but they also were objecting to corrupt courts, forced labour and having their land taken by wealthy nobles. Even churchmen joined in, including the rector of Mayfield and the Prior of St Pancras in Lewes. The rebels occupied London and almost managed to seize the Tower of London. After being promised reforms and pardons they dispersed, but these were soon revoked and the order went out for Cade's arrest. He fled London, pursued by the Sheriff of Kent, who caught up with him in July 1450, in the Heathfield area. Cade was seriously injured and, despite dying on his way back to London, was still executed.

The story of the Cade rebellion was later dramatised by Shakespeare in his play *Henry VI*. The famous quote from this is spoken by a butcher friend of Cade's: 'The first thing we do, let's kill all the lawyers.'

It has been speculated that Cade was actually caught at Hothfield, in Ashford, Kent, a similar sounding place name. Also, Cade Street itself, near Heathfield, probably wasn't named after Cade as many suppose, as it was known as Catte Street back in Saxon times.

To find the stone, begin at the Half Moon pub at Cade Street, then head down the road that leads to Battle (the B2096). Cade's stone is a few minutes' walk on the left.

The Sands of Time

An interesting leftover, still in place in Amberley Church, is a bracket-like device above the pulpit that used to hold a large, elaborate hourglass. Something similar could be found near many a church pulpit in the past.

We have to picture the weekly Sunday scene in years gone by: the vicar, beginning his sermon, would turn the glass over, the congregation watching the sand slowly trickle through, realising he was probably going to speak until the lower portion was completely full – an hour later. And then he might invert it again, for another hour's worth. How this was greeted depended on the eloquence and power of his oratory – or not as the case may be.

The actual glass was stolen in 1970. Today, the holder usually has flowers in it.

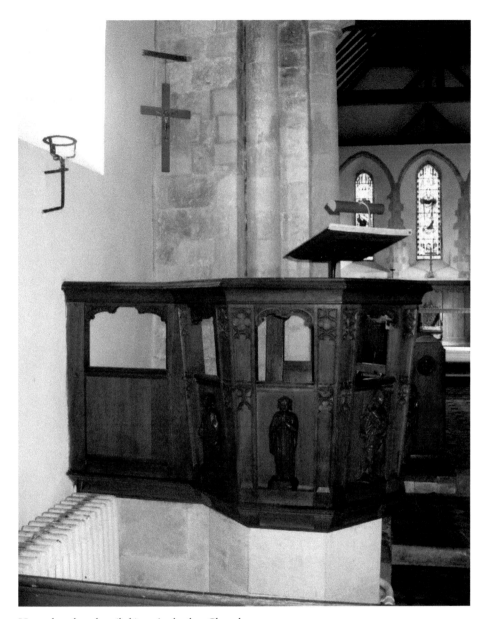

Hourglass bracket (left) at Amberley Church.

Spare a Penny

The little church at Poling has more than its fair share of interesting leftovers from the past. Pictured is a really old poor box, once a common sight across the county, located right next to the main door. It bears the date '1790', but this is probably when it was restored. On the top are the initials and date 'Rt. De HIC

of A 1285'. These refer to an Isabella de Mortimer, one time Countess of Arundel. If the box does date from the thirteenth century, then it's one of the rarest relics in any Sussex church.

The poor box in Poling Church.

Wooden Effigy

In the church at Slindon, west of Arundel, is the tomb of Anthony St Leger from nearby Binsted, who died in 1539. He's depicted wearing armour typical of a knight at the time of the Wars of the Roses. The large codpiece certainly catches the eye and there's been much speculation over the years as to whether some kind of 'comment' was being made about his sexual prowess! His father was Thomas St Leger, one time Sheriff of Surrey and Sussex, who was beheaded for his involvement in a rebellion against Richard III. His mother was Anne of York, Duchess of Exeter. The effigy of their son is the only one in the whole of Sussex carved from wood – every other representation of a person on a tomb is in stone.

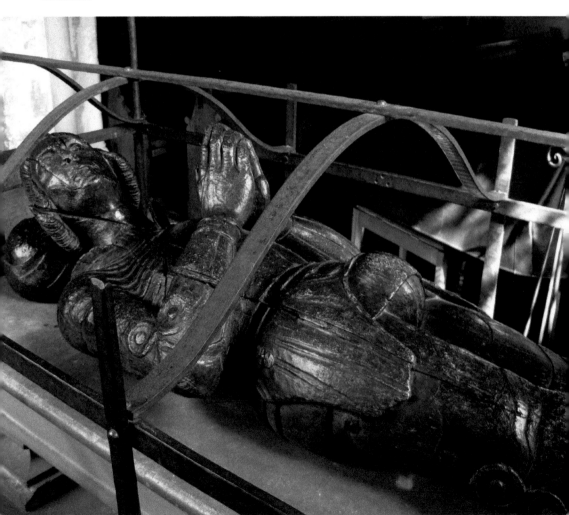

Effigy of Anthony St Leger, Slinden.

One Small Scrap

This small piece of stone is on display at St Mary's Church, Pevensey. It's an ancient fragment of the very first Jewish temple built at Jerusalem by King Solomon, son of King David. It was a huge building – one section was over 200 feet tall – but was destroyed by Nebuchadnezzar II after the Siege of Jerusalem in 587 BC. In 1860, when the remains of the temple were being excavated, the then vicar of St Mary's, Howard Hopley, happened to be at the site. He cheekily chipped a piece off from one of the stones that had been uncovered and pocketed it, to bring back to England as a souvenir of his visit. It's been on show in the church now for well over 150 years.

Stone fragment, St Mary's Church, Pevensey.

Ring of Hope

The picture shows the lock of the ancient door leading from the porch to the nave of St Andrew's Church, Steyning. It's one of the few churches in Sussex that retains its sanctuary ring. In medieval times, someone accused of a crime could run into a church, grasp the ring on the door (if it had one) and claim the sanctuary of the church. This meant they would be free from persecution for forty days. They had to stay in the building and would be looked after – and guarded – by the parishioners. There would be a huge fine if the accused escaped. There were then two options for the individual involved: confess to the crime or flee the country. Confession would obviously bring punishment, even death. Fleeing the country meant a public ceremony at the church gate, where all the criminal's possessions were surrendered, including any land they owned. They would then be escorted onto a road leading to the nearest port and expected to leave the country at the first opportunity.

There are no records of any of this happening at St Andrew's, but it's easy to take the sanctuary ring in your hand when standing at the door and imagine a medieval criminal clutching it and shouting out, 'Sanctuary!' bringing everyone running. The right of sanctuary was finally abolished in 1623.

The sanctuary ring in Steyning's church.

Clear as a Bell

This curious plaque seen in the doorway of All Saints' Church in Hastings is dated '1756' and is a clear warning not to be late if you're one of the bell-ringers:

> This is a belfry, that is free
> for all those that civil be
> and if you please to chime or ring
> it is a very pleasant thing.
>
> There is no musick played or sung
> like unto Bells when theyr well rung
> then ring your bells well if you can
> Silence is best, for every man.
>
> But if you ring in spur or hat
> sixpence you pay be sure of that
> and if a bell you overthrow
> pray pay a groat before you go.

Bell-ringing stipulations at Hastings.

A groat was worth four old pennies, nearly 2p today. So, it was a lesser fine for overthrowing a bell than turning up late wearing your hat or spurs. Overthrowing a bell could break a sliding block at the bottom of the bell frame, which made sure the bell didn't go round in circles. Incidentally, this rhyme isn't unique. There are others in various churches throughout Britain, all very similar and most containing the 'spur and hat' part. Some warn against swearing too.

Captain Scott's Rope

The totally unexpected sometimes turns up in Sussex churches. In *The King's England: Sussex*, published in 1937, it states that in the chapel of Chailey Heritage School (St Martin's), 'a veritable museum' could be seen on its walls and windowsills, with all sorts of interesting artefacts on display. These are mostly still there, and one of the most prized items is a coil of rope from the ill-fated expedition to the South Pole led by Robert Falcon Scott, who, as everyone knows, failed to reach the Pole ahead of the Norwegian Roald Amundsen and perished, with four other companions, on the return journey in 1912. The rope was presented to the school by George Murray Levick (1876–1956), a member of the group that initially accompanied Scott, acting as surgeon and zoologist. He had quite an adventure himself, when, on the journey home, was stranded due to

Rope from Captain Scott's 1912 expedition.

pack ice and had to spend months in an ice cave, with several others, on the bleak Inexpressible Island. He would later acquire some notoriety for a manuscript he wrote on the sexual behaviour of penguins, which so shocked the Keeper of Zoology at London's Natural History Museum, London, he wouldn't publish it (in fact it wouldn't be published until 2012).

Levick's subsequent medical career saw him rise to the rank of surgeon commander and in the First World War he was involved with the Gallipoli campaign. He was medical officer at Chailey Heritage from 1922 until 1950 and pioneered open-air treatments, particularly for children suffering with TB of the bones (of which there were many). He often had rows of camp beds put outside in the sunshine for children to lie on and those who couldn't get out of bed were wheeled onto balconies or had sun lamps installed in their wards. He also controversially pioneered treating blindness by physiotherapy.

Levick founded the Public Schools Exploring Society in 1932 and led many of its early expeditions. He was still its president when he died (when it had been renamed the British Schools Exploring Society). It still flourishes today and has a fascinating website.

Witchcraft Remains

In January 1935, at an auction at Steven's Rooms, King Street, in London's Covent Garden, three bizarre local relics came up for sale connected with witchcraft. One was a witch's hand, described as 'skeletal', which was said to belong to a Sussex witch named Mary Holt, who was hanged at Pulborough 'nearly 200 years ago'. It had been used in the eighteenth century as a 'cure all' and went for £3 15s. As there never was a Sussex witch called Mary Holt and the only witch who was hanged (for killing three people) was Margaret Cooper of Kirdford, this particular item was a total fake.

Also up for auction in 1935 was an item listed as 'a nativity' and described as 'a cross surrounded by quaint charms in a glass-topped box', used 'to cure witchcraft and other diseases'. This sold for £11. A 'heart pierced with pins', another 'witchcraft cure' dating from around 1750, was sold for £1 12s 6d. These last two were probably more authentic, as all kinds of talismans and protective devices were made, often mass-produced, to ward off supposedly malign witchcraft spells.

Arundel's Anvil

Next time you visit Arundel, see if you can spot a rooftop anvil. It's above the shops in the High Street, just below the Norfolk Arms Hotel. In the past it represented the trade of ironmongers and is probably late Victorian; an ironmongery business occupied the site for over a hundred years. Another neighbouring shop has a checkerboard pattern on its roofline, which would have denoted a gunsmith.

Arundel's rooftop anvil.

Ancient Trees

Outside Bexhill's Northern Hotel, in Sea Road, is a portion of tree trunk, which is actually a reminder of how the Sussex coastline has changed a huge amount over the years. At very low tides at the beach below Galley Hill an area of ancient forest becomes exposed, which is now mostly levelled, but roots, shreds of bark, branches and parts of trunks can be found, and sometimes a sapling can be spotted still standing. Occasionally a very large section of tree trunk from further out at sea gets washed up, such as the one displayed outside the hotel. The trees were growing thousands of years ago, probably in the Bronze Age, when the sea level was some 100 feet lower than it is at present.

Examples of amber, which is a fossilised tree sap, have been found, although none with insects trapped inside, and fossil dinosaur footprints are also sometimes exposed on the beach. Most are attributed to iguanodons but megalosaur prints have been found as well.

Ancient tree at Bexhill.

Winds of Change

The weathervane of Etchingham Church bears the simple, criss-cross crest of Sir William de Echyngham, who built the church. The date of completion isn't known, but records show building was taking place in 1368 and work probably finished in 1388. The vane dates from this time too, which almost certainly makes it the oldest in the whole of Britain, probably Europe too, that's still in place and continues to work. It's well over 600 years old. Things were certainly built to last in the past.

Etchingham's weathervane.

Caged Killer

One of the most infamous murders in Sussex took place in Rye, the result of a misplaced, premeditated revenge. This was the murder of Allen Grebell in March 1743. James Lamb, mayor of Rye that year, in the course of his duties as magistrate fined a butcher named John Breads (sometimes spelt Breeds) for giving short weight to his customers. Breads nursed this punishment as a bitter grievance and was determined to avenge it. Shortly afterwards, Lamb was preparing to fulfil an evening mayoral engagement when his brother-in-law Allen Grebell called to see him. Lamb was feeling unwell, so asked Grebell to deputise for him. He agreed, and, as the weather looked bad, Grebell borrowed the mayor's official great coat for the journey. At about midnight Grebell was on his way home, passing through Rye churchyard. In wait behind a tombstone was Breads and, as the coated figure came within range, he sprang out and stabbed who he thought was the mayor with one of his butcher's knives. Grebell staggered home, slumped in a chair and, too weak to raise the alarm, bled to death. As a Cinque Port town, Rye had its own court sessions and gaol, with the mayor usually presiding as the judge. So it came about that Breads was tried for murder before James Lamb. Asked if he had anything to say, he retorted: 'I didn't mean to kill Grebell, I meant to kill you!'

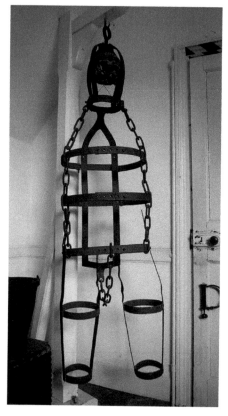

Rye's gibbet cage.

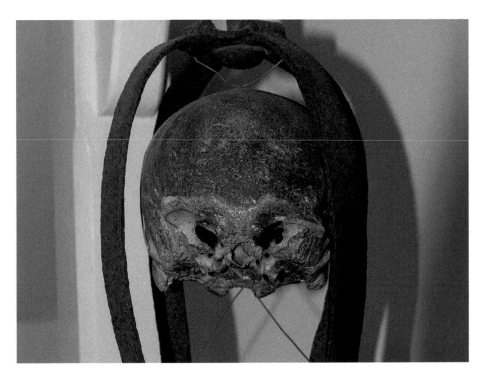

Skull of murderer James Breads.

In June, Breads was hanged and his body gibbeted, suspended in an iron cage, on Gibbet Marsh, west of the town, until it rotted away. It's said that many of the bones were stolen by old women who used them to make up a cure for rheumatism. The cage was there some fifty years, swinging away in the wind, for all to see. One ghastly aspect of this murder is that the gibbeting cage survives to this day, stored in a room above the Town Hall at Rye, and Breads' skull is still inside it. The hook from which it was suspended is chillingly worn away, from where it hung so many years. An authentic replica, containing the full skeleton, can be seen in the Rye Castle Museum. Grebell's grave is under the floor in St Mary's Church.

Taking Stock

In the past, most Sussex towns and villages had a set of stocks where those who had committed minor crimes could be placed and ridiculed. However, as most were wooden and have gradually rotted away, few are to be seen today. The pictures here show the stocks at Midhurst, which are still in good condition and on display near the church. The two men in the old photograph, of around 1905, seem quite happy to be sat in them – almost certainly a posed photograph. The last person in the Midhurst stocks for an actual crime was Henry Eldridge, in 1859, who was sentenced to six hours for not paying a fine.

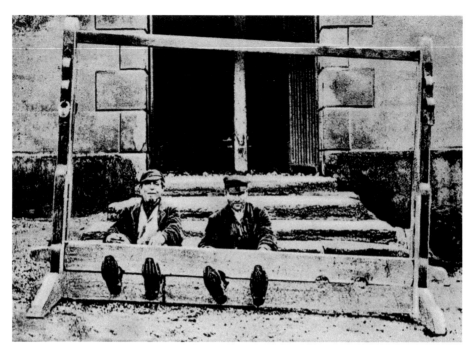

Stocks at Midhurst.

Murder Most Foul

Jacob's Post, on Ditchling Common, marks the site of an old gibbet dating back to the eighteenth century. It isn't as easy to find as it used to be, and it's certainly not the original post on which the body of a murderer was hung.

In May 1734, Jacob Harris, a pedlar, brutally murdered three people at a public house at the northern end of Ditchling Common. This was until recently the Royal Oak, which was demolished in 2018 and replaced by a small housing estate. The three victims were the landlord, Richard Miles, his wife and their maid. He robbed them of clothes and money, running off to the Cat Inn at Turners Hill, with soldiers chasing after him. He then ran on and hid up a chimney at Selsfield House, West Hoathly, but was discovered when the fire was lit and immediately arrested. Landlord Miles, before he died, named Harris as his murderer (he was well known in the area), and the pedlar was imprisoned in Horsham Gaol. He was subsequently tried and executed, and afterwards the body was hung in chains from a gibbet on Ditchling Common close to the scene of the murders. It's said that women who were infertile would visit the corpse while still intact and if they held its hand for a short while would become fertile. Well into the nineteenth century, a fragment of the post (or from any gibbet), carried on the person, was considered a cure for both toothache and epilepsy. The original post was eventually reduced to a stump and replaced several times over the years, with an original section on display at the Royal Oak, hanging above the bar. The rooster on top, although dated 1734, is a modern replica.

Jacob's post, Ditching Common.

To find the post, head along the road from Ditching to Haywards Heath, the B2112. A hundred or so yards before the sign for Wivelsfield, there's a turning off to the left for a large house named Bankside. Park safely and approach this property down the short road, but turn off left into the wooded area. Move through the trees to where the post stands.

Of Mice and Men

Sussex has been home to some pretty odd factories and workplaces over the years. None more bizarre though than the premises owned by Colin Pullinger at Selsey in Victorian times. His trade card read:

COLIN PULLINGER SELSEY near Chichester CONTRACTOR, INVENTOR, FISHERMAN and MECHANIC, Following the various trades of a Builder, Carpenter, Joiner, Sawyer, Undertaker, Turner, Cooper, Painter, Glazier, Wooden Pump Maker, Paper hanger, Bell hanger, Sign Painter, Boat Builder, Clock Cleaner, Repairer of Clocks and Keys Fitted. Repairer of Umbrellas and Parasols. Mender of China and Glass. Copying Clerk, Letter Writer, Accounts, Teacher of Navigation. GROCER, BAKER, FARMER. Assessor and Collector of Taxes, Surveyor, House Agent, Engineer, Land Measurer, Assistant Overseer, Clerk at the Parish Vestry Meetings, Clerk to the Selsey Police, Clerk to the Selsey Sparrow Club.

Has served at sea in the four Quarters of the World as Seaman, Cook, Steward, Mate and Navigator. The Maker and Inventor of the following: An improved Horse Hoe, An Improved Scarifier, a newly invented Coach, Grass Rake, a machine to Tar Ropes. Model of a Vessel to cut-asunder Chains put across the Mouth of a Harbour. A CURIOUS MOUSE TRAP Made on a Scientific Principle, where each one caught resets the Trap to catch its next neighbour, requires no fresh baiting, and will catch them by the dozens.

In fact, it was this last invention, the mousetrap, that Pullinger's factory became most famous for, and it became known as 'the mousetrap factory' despite all the other devices it produced. At the height of its working life over forty men and boys were employed. When Pullinger died in 1894 his son carried on the business,

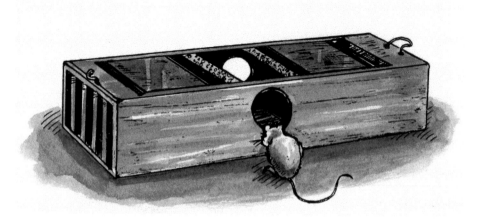

A Pullinger mousetrap.

and it finally closed in the early 1920s. The factory no longer exists, but the site corresponds to Selsey Town Council's offices in the High Street. A commemorative blue plaque is on the wall.

The picture shows one of the mousetraps, which was around 14 inches long. The mouse entered a small, round hole at the side and was tipped by a see-saw mechanism into one of the end chambers, and kept there until released through a tin slide at the bottom of the trap. The bait, which was wheat, was visible to the mouse through glass panels on the top, which obviously would tempt it inside.

Apparently, Pullinger didn't intend the mice to be killed once caught, but carried away while still in the 'mouse carriage' and released into the wild. These traps cost 2s 6d (some 13p today), were very solidly built and intended to last a lifetime. Some 2 million were produced overall. Several are on show at Chichester Museum.

The Rat and the Spoon

And while on the subject of rodents…

Two of the most curious items to be found at the Anne of Cleves House Museum, Lewes, are this mummified rat and silver spoon, displayed side by side. Very few details are known about the find. Apparently a serving girl was accused

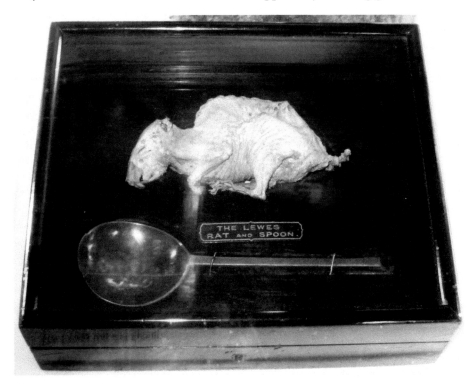

Rat and spoon from the Anne of Cleves House Museum, Lewes.

of stealing the spoon from her employers and dismissed, despite protesting her innocence. Years later, the spoon was discovered in a cavity, along with a partly mummified rat. Did the rat purloin the spoon, causing the servant to lose her job? Probably not, but a vision of the creature scurrying away with it in his mouth and secreting it in his nest somewhere makes for a good story.

Lion Around

Westgate Street in Lewes is now a car parking area, but once contained a number of small cottages and an inn, the White Lion, all demolished in 1937 as part of a slum-clearance scheme. The street's original name was White Lion Street, and the inn may well have existed as far back as Elizabethan times. The inn's sign was a striking lion sculpture, with his paw on a sphere (the world?), which was saved from the scrapheap following clearance, and the council assumed custody of it. In 1954, Mayor G. R. Beard gave it to the Friends of Lewes, who arranged for it to be remounted on the wall in Westgate Street, which, incidentally, is one of the ancient town walls of Lewes. However, recently it was discovered that the lion

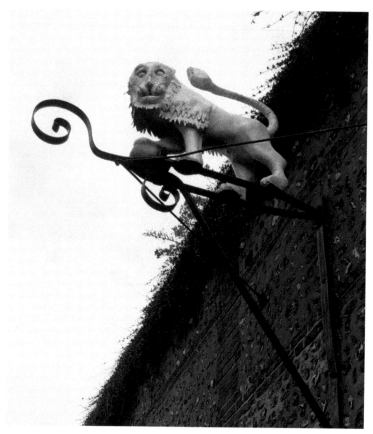

Lewes's white lion.

was made of iron, coated in copper and valuable if stolen, so a replica was made, which is on the wall today, described online as 'plasticky looking' by one Lewes resident. The original seems to be back with the council, which prompted another Lewes wag to comment that meant, 'in ten years time they will have lost it!'

The first sign was made by Abraham Larwill, a Lewes man, in the early nineteenth century, at a time when he advertised himself as, 'Tinplate worker, brazier and wire worker to HRH the Prince of Wales.' A Larwill family resided at Nos 152–53 High Street at the time the lion was created, so it seems likely its maker lived just a short distance away.

Toad in the Hole

Another Lewes relic worthy of mention is a 'Toad in the Hole' game, which is still in use by regulars at the town's Lewes Arms pub. Ah, the simple pleasures of the past! The aim is to pitch discs into the hole of the 'board' (made of lead); two points if you manage it, one if it comes to rest on the edge (so 'a near miss').

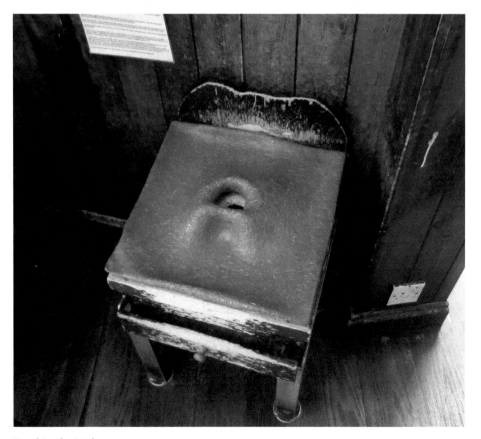

Toad in the Hole game.

Compare this to a modern Xbox and computer games, smartphones and all the myriad of distractions offered by the internet. There's a more intricate version of 'Toad in the Hole' on show at Horsham Museum, which is bigger with more winning holes and even sports a model toad with an open mouth, ready to receive a top-scoring disc.

Dainty Leftovers

Elizabeth I made a royal progress through Sussex in 1573. Travelling from Kent, she stayed at several Sussex locations during her trek (progressing at around 12 miles a day), including Mayfield Palace, near St Leonards, home of Sir Thomas Gresham, today a girls' boarding school. The great hall, where Elizabeth was

Postcard souvenir of Elizabeth I's tree.

almost certainly wined and dined, is now the school chapel. She also stayed at a large shooting lodge at Eridge, owned by Lord Bergavenny.

Her next stop was Northiam. On the village green, near the church, stands an aged oak tree marking the spot where Elizabeth enjoyed a meal 'al fresco' prepared by a local family named Bishop. The queen left behind a lasting memento of her visit: a pair of green silk shoes. For years these were on display at Brickwall House at Northiam, today owned by the Frewen Educational Trust, with the shoes now in the possession of the Frewen family. The tree the queen sat under is still there, and for many years souvenir postcards of it could be bought.

Finally, on reaching Rye, Queen Elizabeth was so pleased with her reception, which seems to have been really over the top, she gave permission for the town to call itself 'Rye Royal', a title that never seemed to be taken up.

In August 1591, the queen was again in Sussex, staying at Cowdray House, near Midhurst, where she went hunting. She killed a deer with a crossbow and for years the weapon was proudly displayed, hanging among the stags' heads mounted on the wall of the great hall. Henry VIII had also been entertained at Cowdray in 1538. As previously described, the house famously burnt down in 1793 and has stood for years as an extremely picturesque ruin.

Royal Reminder

In Chichester's well-known market cross is a bust of Charles I, a reminder of a turbulent period for the city during the Civil War (1642–51). As mentioned earlier, the country was then in total upheaval due to divided loyalties between the king and Parliament, and indecision over who should ultimately rule. Chichester had many loyal to the throne, but others robustly supported Oliver Cromwell, and his desire to replace the king's 'divine right' of rule with a republican system based on elected representatives. Simmering tensions bubbled up late in 1642 and the city found itself besieged. Prominent Parliamentarians had to flee when a Royalist force of some 1,000 men entered the city, claiming it for the king. In late December, they too had to parley surrender when a Parliamentarian force arrived and took control. Chichester then remained a garrison under Cromwell's rule until 1646, by which time Charles was defeated. He would be allowed to remain king as a figurehead, but proved perfidious and would not stick to any agreement on his role. In January 1649, he was executed on a charge of high treason.

The bust of Charles, commemorating all this, was presented to Chichester at the restoration and installed in the cross. It was later removed to the city's council offices for safekeeping and a replica put in its place. The original found its way to Tate Britain, but was returned to Chichester for a while, on loan, seen at the Novium Museum in Tower Street, along with a facsimile of Charles I's death warrant, which contained several Sussex signatories.

Bust of Charles I in
the Market Cross at
Chichester.

The King Loses His Shirt

A Sussex man was among the officials on the scaffold when Charles I was executed. The individual involved was John Ashburnham (1603–71), who had served the king as 'groom of the bedchamber' and was a personal friend for many years. The Ashburnham family were involved with the Sussex iron industry and were exceptionally wealthy and influential. The family seat was Ashburnham House, near Battle.

Following the king's death, John remained a staunch Royalist, but as he'd been involved with several escapes planned for king he was held captive in the Tower of London, then banished from the country for a number of years. He regained full royal favour at the Restoration, allowing him to reconstruct Ashburnham House, which eventually stood in over 900 acres of grounds, the work of landscape artist 'Capability' Brown.

In the local church, John put on display several relics of the execution that he'd acquired, including the shirt (one of two) worn by Charles, his watch, a pair of

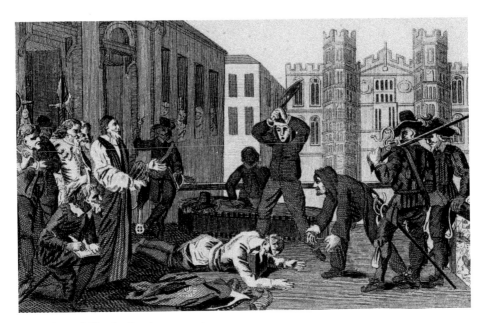

Execution of Charles I, 1649.

silk drawers, two garters, a lock of hair, plus the sheet thrown over the king's dead body while awaiting the head to be sewn back on prior to burial. There is a record of a sick child being wrapped in the sheet in 1859 in the hope the affliction would be cured. A theft of the watch case in 1830 saw the relics removed to Ashburnham House, where they remain today. The last of the Ashburnhams died in 1953, which saw the house contents sold off, followed by partial demolition. Today, what remains is a Christian meeting centre.

Off the Rails

In the grounds of Lewes Castle are a small section of the railings that used to surround London's St Paul's Cathedral, designed by Sir Christopher Wren and built between 1675 and 1710. Originally, he didn't want the cathedral surrounded by railings, but he later changed his mind, and a large number were cast at the Gloucester ironworks at Lamberhurst, a foundry dating from 1695. Years later, in 1873, it was decided to improve the western approach to St Paul's to provide better public access, and nearly 400 feet of railings were removed. A large section was acquired by the Victoria and Albert Museum, some pieces went to other museums (a gate was donated to the one at Hastings), others went abroad, some were even reused, such as outside the War Memorial Hall at Lamberhurst. How a small section came to be on display at Lewes Castle isn't known, but they've been there for many years, easily overlooked by visitors.

Railings from St Paul's Church, on show at Lewes Castle.

Ticket to Ride

This last little relic from the past won't amuse rail commuters at all. It's a weekly Southern Railway ticket of July 1943, for use between London and Brighton, costing £1 13s 6d (£1.68 today). The cost of an identical weekly adult ticket in 2021 (when this book was compiled) is £105.20. Yes, everything was cheaper back in the 1940s, but inflation takes on a whole new meaning when comparisons like this are made!

London to Brighton season ticket.

Acknowledgements

Much of what appears in this book originated in articles written for *Sussex Life* magazine, starting in December 2002. The old *Sussex County Magazine* (published from 1926 to 1956) proved a fathomless source of information for these, and a bound set of some thirty volumes is available to all at Worthing Library. David Arscott's *Hidden Sussex* titles, published in the 1980s, provided numerous starting points for investigating places.

All sorts of people have helped with research over the years, many of them local to whatever village or town I was visiting, responding eagerly to questions or providing the directions needed to find precise locations.

Most of the photographs originate from my own camera. I would like to thank Rye Museum Association for the pictures of the gibbet cage, and the one of the rope from Captain Scott's South Pole expedition was provided by Helen Hewitt, Chief Executive of the Chailey Heritage Foundation. The Sussex Archaeology Society permitted several relics from the Anne of Cleves House, Lewes, to be included. The photograph of the three cubist houses at Saltdean is courtesy of Douglas d'Enno. David Arscott kindly allowed me to quote from his book *Hidden Sussex Day by Day*.

Also by the Author

Chris Horlock's companion book to this one is *Illustrated Tales of Sussex*. The content is almost entirely different, but again focuses on the offbeat, quirky aspects of the county's history and includes more interesting remains, strange happenings and phenomena, hoaxes and witchcraft, plus some new reminiscences on smuggling. Several hill figures, including the Long Man of Wilmington and Litlington's White Horse, are also featured, plus visits from individuals not usually associated with Sussex, including Guy Fawkes, Vincent van Gogh and John F Kennedy.

Still available at bookshops and online, or direct from the publisher: amberley-books.com / (+44) 1453 847800. ISBN: 9781445678993.

Illustrated Tales of Sussex.